ANXIETY

ANXIETY

Orthomolecular Diagnosis
and Treatment

DR JONATHAN PROUSKY,
BPHE, BSc, ND, FRSH

Introduction by Dr Abram Hoffer, MD, PhD, FRCP(c)

CCNM
PRESS

ISBN 1-897025-23-8

Edited by Bob Hilderley.
Design by Sari Naworynski.

Printed and bound in Canada by Tri-Graphic Printing, Ottawa, Ontario.

Published by CCNM Press Inc., 1255 Sheppard Avenue East, Toronto, Ontario M2K 1E2 www.ccnmpress.com

CONTENTS

PREFACE

In a seminal article published 1968 in the journal *Science*, Dr Linus Pauling first used the term orthomolecular when he defined orthomolecular psychiatry as "the treatment of mental disease by the provision of the optimum molecular environment of the mind, especially the optimum concentrations of substances normally present in the human body."[1]

In this landmark article, Pauling offered various reasons why an optimum intake (megadose) of specific nutrients would probably benefit mental disease. He argued that the saturating capacity would be much greater if defective enzymes could restore their combining capacity for their respective substrates. In other words, an enzyme-catalyzed reaction could be corrected by increasing the concentration of its substrate through the use of optimal doses of particular micronutrients. He discussed the possibility that cerebrospinal fluid (CSF) concentrations of vital substances (e.g., micronutrients) could be grossly diminished, while concentrations in the blood and lymph remained essentially normal. Localized cerebral deficiencies might occur because of decreased rates of transfer (i.e., decreased permeability) of vital substances across the

blood-brain barrier, increased rates of destruction of vital substances within the CSF, or other factors.

In this book, I follow Professor Pauling's original ideas and relate them to the orthomolecular diagnosis and treatment of anxiety disorders. To my knowledge, this is the first book to focus on anxiety disorders from an orthomolecular perspective. I make no apologies for this bias. In my practice, the orthomolecular approach has proven to be restorative when treating patients who suffer with debilitating anxiety.

Even though I am convinced that the orthomolecular approach is clinically efficacious, many people will criticize it due to the relative absence of high-quality randomized controlled trials (RCTs). In spite of this criticism, clinicians who practice orthomolecular medicine have witnessed numerous patients recover from mental disorders due to the restorative properties of these methods. To best summarize my point, let me quote from a book on orthomolecular medicine written more than two decades ago: "Every orthomolecular physician can tell of dramatic recoveries in patients who had previously failed to respond to any other therapy. Each recovery is a sparkling jewel added to the warehouse of precious memories. Recoveries from disease for patients are the doctor's immutable rewards beyond price."[2]

During 7 years of clinical practice, I have seen hundreds of patients benefit from the orthomolecular approach – these are my rewards. I am convinced that this is the most effective way to manage and even eliminate the debilitating symptoms of anxiety. Patients who stick with it usually experience favorable results within a few months. This is the only approach that facilitates optimal mental health without producing drug dependency, discontinuation side effects, and other complications.

While it cannot be disputed that RCTs are the gold standard for evaluating treatment efficacy, most of the orthomolecular treatments described in this book have published data confirming clinical utility and efficacy. I have attempted to synthesize much of this confirmatory data on orthomolecular treatments in the evidence-based summaries at the end of each chapter. These summaries should provide even the most conservative of clinicians with some comfort in knowing that a body of medical literature does support the orthomolecular approach.

An alternative method by which to examine the orthomolecular evidence is to determine if any of the cited references confer biological and/or clinical plausibility. Biological plausibility is conferred when biochemical, tissue, and animal data point to mechanisms of action or demonstrate the desired biological effects.[3] In terms of the vitamin niacinamide, numerous reports from experiments done on animals substantiate biological plausibility and give merit to its anti-anxiety properties. Many of the other nutritional treatments have published data conferring biological plausibility as well.

Clinical plausibility is conferred when there is data from several sources, such as epidemiological, case reports, case series, and small formal open or controlled clinical trials.[3] Once again, niacinamide has evidence of clinical plausibility: there are many published case reports demonstrating efficacy and suggesting the potential for RCTs. Many of the other nutritional treatments demonstrate clinical plausibility because there are published case reports, case series, and even small controlled and experimental trials on many of them.

All treatments with any evidence of biological and/or clinical plausibility are worthy of more definitive clinical testing.[3] The best way to achieve this would be to subject the orthomolecular treatments to high quality RCTs. This would elevate the orthomolecular approach into the mainstream medical system. Someday, there will be RCTs confirming the orthomolecular approach. The absence of definitive proof is not proof of absence of clinical efficacy. Hundreds of thousands of trusting patients depend on their clinicians to offer safe, effective, and proven care; many patients hope for restorative treatments for anxiety.

In the meantime, I invite clinicians to take this approach with their patients and continue research in this promising field of clinical nutrition. If the correct causes of anxiety are addressed and optimal doses of nutrients are used, I believe that many patients will show clear benefits within a few months. I am asking clinicians to submit documented case reports, which describe their results with orthomolecular treatments. I hope to include some of these clinical reports, along with the results of further research studies, in future editions.

Correspondence can be sent by e-mail or regular mail to:

Jonathan E. Prousky, ND, FRSH

Chief Naturopathic Medical Officer

Associate Professor, Clinical Nutrition

The Canadian College of Naturopathic Medicine

1255 Sheppard Avenue East

Toronto, Ontario

Canada M2K 1E2

Email: jprousky@ccnm.edu

Tel: 416-498-1255 ext. 235

Fax: 416-498-1611

References

1. Pauling L. Orthomolecular psychiatry. *Science* 1968;160:265-71.

2. Hoffer A, Walker M. *Orthomolecular Nutrition.* New Lifestyle for Super Good Health. New Canaan, CT: Keats Publishing, Inc., 1978:174.

3. Hoffer LJ. Complementary or alternative medicine: The need for plausibility. *CMAJ* 2003;168:180-82.

INTRODUCTION

This book, linking anxiety, one of our major emotional disabilities, to inadequate diet and food allergy, will one day be viewed as a fundamental text on how to prevent and treat anxiety states.

Psychiatry is gradually becoming more biochemically oriented. It's about time. In 1954, when I traveled to England as a Rockefeller Travel Fellow, I first met Dr Jonathan Gould, a Harley Street psychiatrist. Dr Gould had previously reported in the medical literature that some patients with organic or confusional psychosis could be helped by giving them intravenous vitamin B-complex solutions. He also told me about a double-blind controlled trial on children with poliomyelitis. The half given large doses of vitamin C made a complete recovery, but a handful of children from the placebo group were left permanently impaired. That same year, our research group in Saskatchewan proposed the adrenochrome hypothesis of schizophrenia, suggesting that schizophrenic patients made too much adrenochrome, an hallucinogen, from their adrenalin. Administering large doses of vitamin B-3 proved to be effective in treating not only acute but also chronic cases of this psychiatric condition.

Since then, my research activities and medical practice have focused on treating the psychotic group in our mentally sick population using optimum nutrition and orthomolecular medicine. While I have seen very good responses with other conditions, including anxiety disorders and behavioral problems, I did not pursue the link between anxiety states and nutrition until reading initial reports on this connection by Dr Jonathan Prousky, published in the *Journal of Orthomolecular Medicine*. I was very pleasantly surprised when I discovered that Dr Prousky was following the lead of Professor Linus Pauling, who gave this approach to nutrition, medicine, and psychiatry the name orthomolecular. If Dr Prousky's work had been published decades ago, I would have depended much less on drug treatments for anxiety states, with their undesirable side effects, and more on the use of nutrition and supplements.

This is the first book that applies orthomolecular principles to the theory and treatment of the anxiety disorders. The book has wider implications, however. Anxiety is ubiquitous and presents with almost all the physical and psychological discomforts known in the entire domain of psychiatry. Anxiety is, of course, a basic human, perhaps mammalian, characteristic and must have once had a major evolutionary advantage. Anxiety is part of the flight or fight mechanism, involving the sympathetic nervous system, adrenalin, noradrenalin, and dopamine, as well as their oxidized derivatives due to oxidative stress.

Anxiety is also one of the first symptoms of many of the B-vitamin deficiency diseases. It is common in pellagra and beri beri. One of the first indicators that there is a metabolic problem with the biochemistry of the body is anxiety, which is generated because these biochemical abnormalities present a major threat to the body. It makes sense that a large proportion of people suffering from anxiety disorders may have a B-vitamin deficiency and will need optimum amounts of the one they need the most.

My favorite vitamin, B-3, stands high on the list of important anti-anxiety compounds. I consider this vitamin to be one of the major natural anti-anxiety or anti-adrenalin mechanisms our body uses. One of the toxic effects of adrenaline is to release fatty acids from the storage sites, leading to many cardiovascular problems. Niacin protects the body against this toxic effect of adrenalin. Other patients may need therapeutic doses of vitamin B-12, pyridoxine, pantothenic acid, and inositol.

This discovery is very fortunate for humanity because, one day, when the healing professions adopt orthomolecular theory and practice, they will develop very specific laboratory methods of determining exactly what nutrients are missing from our biochemistry, what nutrients should be supplied, and in what doses to insure optimum health and lifelong well-being.

Dr Prousky leads the way. Many studies will surely follow. This work is important. Just think about how many people will not have to suffer from excessive anxiety, depression, chronic disability, and even death if this approach to treating anxiety disorders is widely adopted in mainstream nutritional and medical practice.

— Dr Abram Hoffer, MD, PhD

PSYCHOLOGY AND PHYSIOLOGY OF ANXIETY DISORDERS

① |

Anxiety disorders are the most common psychiatric disorders in the United States.[1] They are extremely debilitating for the suffering individual, disrupting the ability to engage in a full, functional life. The consequences of anxiety are profound with emotional, occupational, and social impairments.

Common Symptoms

Some of the common somatic symptoms of anxiety are facial flushing, hyperhydrosis (excessive sweating), muscle tension, paresthesias (numbness and tingling), shallow breathing, syncope (fainting), and tachycardia (rapid heart rate). The emotional symptoms of anxiety disorders occur simultaneously with the somatic ones and include agitation, derealization (feelings of unreality), fearfulness, feelings of "impending doom," irritability, nervousness, and shyness.

Patients with anxiety disorders often report escape and avoidance

behaviors that merely reinforce and perpetuate their ongoing anxiety. They also tend to engage in catastrophic thinking by over-predicting the negative consequences of events.[2] Patients tend to misinterpret benign bodily sensations as warning signals for more serious conditions. Heart palpitations, for example, are a common complaint of the anxiety sufferer, yet this symptom is often misinterpreted as a heart attack. These patients desperately want their anxiety to go away, but cannot control it.

Adaptation

These patients also suffer from a heightened autonomic nervous system (ANS) reaction to a perceived threat. There might be a link between the anxiety of modern times and the lifesaving mechanism that was required of our prehistoric ancestors.[3] For example, when the early hominids had to hunt and kill to feed themselves, they had to mobilize and react to threats to their survival. By contrast, the anxiety sufferer of today manifests the same mobilization as if fleeing from a predator, but this mobilization is out of proportion to the actual threat. In some of us, anxiety, therefore, might be built into our genes. Evolution might favor those who have anxiety, for it makes sense to have a built-in system that ensures survival.[3] Better to have a system that gives more false positives then false negatives. The advantage might be survival, but at a tremendous cost if the sufferer faces a lifetime of discomfort. Thus, it might be said that evolution favors anxious genes.

Incidence

Most patients with anxiety disorders seek help from a primary care physician rather than a psychiatrist.[4] In a recent survey of 2,316 randomly selected patients (age 18 years and older) seen by general practitioners, 42.5% of all patients had evidence of a threshold/subthreshold psychiatric disorder.[5] In the same survey, anxiety disorders were found in 19% of all patients. In a survey of 88 outpatients in an internal medicine clinic, 30% of patients had mixed anxiety features, 33% had generalized anxiety symptoms, almost half reported obsessive-compulsive personality symptoms, and about one quarter had marked levels of worry.[6] The investigators concluded that

anxiety disorders are more common in primary care settings than previously reported.

Lifetime Consequences

Anxiety sufferers commonly report their health as poor;[7] many smoke cigarettes and abuse other substances.[8] These patients have an increased chance of developing chronic medical illnesses (e.g., chronic obstructive pulmonary disease, diabetes, and hypertension) compared to the general population.[9] When they acquire a medical illness, it is often prolonged as a result of their anxiety.[8] Many patients remain untreated and under-diagnosed years after their initial anxiety, leading to unremitting impairment in functional status and poor quality of life. Table 1 summarizes the lifetime consequences of anxiety.

Anxiety disorders are real medical problems with significant consequences. Adequate treatments should be provided to mitigate the suffering of these patients. Orthomolecular treatments, including vitamins, minerals, and food allergy avoidance, can be effective in most cases of anxiety.

Table 1: Lifetime Consequences Of Anxiety

- Poor health as reported by patients
- Increased chance of developing chronic medical illnesses (e.g., chronic obstructive pulmonary disease, diabetes and hypertension) compared to the general population
- Medical illnesses often prolonged as a result of anxiety
- Higher risk of suicide
- Cigarette smoking and other substance abuse

References

1. Kessler RC, McGonagle KA, Zhao S, et al. Lifetime and 12-month prevalence of DSM-III-R psychiatric disorders in the United States. Results from the National Comorbidity Survey. Arch Gen Psychiatry 1994;51:8-19.

2. Shear MK. Optimal treatment of anxiety disorders. Patient Care 2003; May:18-32.

3. Beck AT, Emery G, Greenberg RL. Anxiety Disorders and Phobias. New York, NY: Basic Books, 1985:4.

4. Shear MK, Schulberg HC. Anxiety disorders in primary care. Bull Menninger Clin 1995;59:A73-85.

5. Ansseau M, Dierick M, Buntinkx F, et al. High prevalence of mental disorders in primary care. J Affect Disord 2004;78:49-55.

6. Sansone RA, Hendricks CM, Gaither GA, et al. Prevalence of anxiety symptoms among a sample of outpatients in an internal medicine clinic: A pilot study. Depress Anxiety 2004;19:133-36.

7. Katon WJ, Von Korff M, Lin E. Panic disorder: Relationship to high medical utilization. Am J Med 1992;92:7S-11S.

8. Shader RI, Greenblatt DJ. Use of benzodiazepine in anxiety disorders. New Engl J Med 1993;328:1398-1405.

9. Wells KB, Golding JM, Burnam MA. Psychiatric disorder in a sample of the general population with and without chronic medical conditions. Am J Psychiatry 1988;145:976-81.

STANDARD MEDICAL DIAGNOSIS
OF ANXIETY DISORDERS

②

To diagnose anxiety disorders, it is necessary to rule out organic causes before a psychiatric diagnosis can be made. Certain questions should be posed during the history when evaluating the anxious patient, as posed in Table 2.[1]

Table 2: Questions To Ask The Anxious Patient

1. *Is the anxiety constant or intermittent?* If intermittent, the work-up should focus on psychomotor epilepsy, pheochromocytoma, insulinoma, or intermittent cardiac arrhythmia, such as paroxysmal supraventricular tachycardia or atrial fibrillation.

2. *What is the patient's age?* Young or middle-aged patients likely have an anxiety disorder. Older patients, by contrast, might be suffering from cerebral arteriosclerosis or other types of dementia.

3. *Is the tachycardia present during sleep?* If present during sleep, causes such as caffeinism or other drug effects and hyperthyroidism need to be considered.
4. *Has there been any weight loss?* If there is weight loss and tachycardia, hyperthyroidism is likely.

Tests

Once a thorough history has been obtained, the diagnostic work-up involves various tests depending on the nature of the anxiety.[1] If the anxiety was found to be intermittent, it might be necessary to perform a wake-and-sleep electroencephalogram (EEG) and possibly a computed tomography (CT) scan to rule out a cerebral tumor. In addition, the work-up might require a 24-hour urine collection for catecholamines (to rule-out pheochromocytoma) or a 24-hour Holter monitor (to rule-out paroxysmal cardiac arrhythmia). If the anxiety is more constant than intermittent, the work-up involves other tests, such as a thyroid panel (to rule-out hyperthyroidism), a drug screen, and an EEG. In cases of chronic anxiety, a 24-hour Holter monitor might also be helpful.

Causes

Anxiety has various causes, including medical conditions, lifestyle, medications, and toxins. Some of the main medical conditions that can cause anxiety are listed in Table 3.[2] Anxiety can also be caused by the direct physiological effects of certain medications or toxins, or as a result of withdrawal from alcohol, cocaine, sedatives, hypnotics, or anxiolytics. There is a high comorbidity of alcohol and anxiety problems. The clinician needs to screen all patients presenting with anxiety for alcohol abuse/dependence.[2] The different substances that can directly cause anxiety symptoms are listed in Table 4.[2]

Table 3: Medical Conditions That Can Cause Anxiety

System Involved	Conditions
Cardiovascular	Arrhythmia
	Congestive heart failure
	Coronary artery disease
	Pulmonary embolism
Endocrine/Hormonal	Cushing's syndrome
	Hyper/hypothyroidism
	Hypoglycemia
Metabolic	Porphyria
	Vitamin B-12 deficiency
Neurological	Encephalitis
	Neoplasms
	Temporal lobe epilepsy
Pulmonary	Asthma
	COPD
	Pneumonia

(Adapted from: Uphold CR, Graham MV. Anxiety Disorders. Clinical Guidelines in Family Practice. 3rd ed. Gainesville, FL: Barmarrae Books, 1998:109.)

Table 4: Substances That Can Cause Anxiety Symptoms

Category of Substances	Various Types
Medications	Anesthetics
	Analgesics
	Stimulants
	Anticholinergics
	Insulin
	Thyroid preparations
	Antihistamines
	Corticosteroids
	Antihypertensives
	Anticonvulsants
	Antipsychotics
	Antidepressants

Category of Substances	Various Types
Dietary Substances	Alcohol
	Caffeine
Illicit Substances	Cannabis
	Cocaine
	Hallucinogens
	Inhalants
Accidental/Purposeful Exposure To Volatile Substance	Gasoline
	Paint
	Insecticides
	Carbon monoxide
Withdrawal from Substances	Alcohol
	Cocaine
	Sedatives
	Hypnotics
	Anxiolytics

(Adapted from: Uphold CR, Graham MV. Anxiety Disorders. Clinical Guidelines in Family Practice. 3rd ed. Gainesville, FL: Barmarrae Books, 1998:108.)

Psychiatric Diagnosis

When the work-up does not reveal an organic cause or when the history strongly indicates a non-organic cause of anxiety, a psychiatric diagnosis needs to be considered. Anxiety disorders are classified into various categories, such as generalized anxiety disorder (GAD), obsessive-compulsive disorder (OCD), panic disorder (PD), posttraumatic stress disorder (PTSD), and social phobia/social anxiety disorder (SAD).[3] A brief description of the main types of anxiety disorders is provided in Table 5.

To make an appropriate psychiatric diagnosis, it is necessary that certain criteria be met for the anxiety disorder being considered. Diagnostic criteria necessary for each of the anxiety disorders is presented in the *Diagnostic and Statistical Manual of Mental Disorders* (DSM).[3] Most patients do not meet the criteria necessary for a diagnosis of a primary

anxiety disorder; rather, patients usually have a diagnosis pertaining to one of the following four categories:

1. Adjustment disorder with anxious mood
2. Anxiety due to a general medical condition
3. Substance-induced anxiety disorder
4. Anxiety associated with another psychiatric condition[2]

Table 5: Main Types of Anxiety Disorders

1. **Generalized Anxiety Disorder:** Patients worry constantly; they have great difficulty trying to control their worries and may have similar symptoms to those seen in depressive disorders.
2. **Obsessive-Compulsive Disorder:** Characterized by recurrent or persistent mental images, thoughts, or ideas with compulsive behaviors that are repetitive, rigid, and self-prescribed (sometimes ritualistic) in order to prevent the associated obsession.
3. **Panic Disorder:** Characterized by periodic attacks of anxiety or terror that may occur with or without agoraphobia.
4. **Posttraumatic Stress Disorder:** A re-experiencing of symptoms, avoidance, and hyperarousal after exposure to a traumatic event.
5. **Social Anxiety Disorder:** Patients fear negative evaluations by others or public scrutiny and humiliation. They demonstrate extreme shyness and discomfort in social settings.

Diagnostic Problems

The medical diagnosis of an anxiety disorder can be arbitrary. Two clinicians evaluating the same patient with complaints of anxiety will likely give two different diagnoses. Despite different diagnoses, treatments for the nine descriptive DSM classifications are relatively the same. The other non-primary categories of anxiety are also given almost identical mainstream treatments.

The medical diagnosis of an anxiety disorder does not, therefore, affect care choices because the treatments are much the same for all anxiety diagnoses. In a 1999 article pertaining to the diagnosis of schizophrenia,

A. Hoffer summed up the problem with the current system of psychiatric diagnosis: "In psychiatry we are still in the pre-rational stage of diagnosis. All psychiatric diagnosis is descriptive and has almost nothing to do with cause, nor does it have much to do with treatment. Thus, of the approximately 50 different diagnostic terms (with code numbers) for disturbed and sick children, no matter what the final code or word is, the modern treatment is the same – ritalin – and lip service to psychotherapy."[4]

The most important aspect of evaluation involves ruling out organic cause(s) and making certain that alcohol abuse/dependence is not a factor in the patient's complaint of anxiety.

References

1. Collins RD. Anxiety. Algorithmic Diagnosis of Symptoms and Signs: A Cost-Effective Approach. Pennsylvania, PA: Lippincott Williams & Wilkins, 2003:35-36.

2. Uphold CR, Graham MV. Anxiety Disorders. Clinical Guidelines in Family Practice. 3rd ed. Gainesville, FL: Barmarrae Books, 1998:106-13.

3. Diagnostic and Statistical Manual of Mental Disorders. 4th ed. Text Revision. District of Columbia. American Psychiatric Association, 2000.

4. Hoffer A. Diagnosing schizophrenia: Past, present and future. J Orthomol Med 1999;14:3-15.

STANDARD MEDICAL TREATMENT OF ANXIETY DISORDERS

③

Mainstream treatments of anxiety involve cognitive behavior therapy (CBT), pharmacologic therapies, or a combination of both approaches.

Cognitive Behavior Therapy

CBT is often used for symptom management by employing various techniques, such as applied relaxation, exposure *in vivo*, exposure through imaging, panic management, breathing retraining, and cognitive restructuring.[1] The cognitive part of CBT focuses on the identification of misinterpreted feelings and the education of patients about their anxieties and/or panic attacks. The behavior therapy component uses breathing exercises, relaxation, and exposure as a means to manage the anxiety. There is good evidence that CBT is effective for the treatment of anxiety disorders through regular sessions with a therapist or through self-directed methods, such as videotapes or books, despite minimal contact from an actual therapist.[1]

Pharmacologic Therapies

Benzodiazepines

The benzodiazepines are the most commonly prescribed medications. These are listed in Table 6.[2] Benzodiazepines bind to a macromolecular complex that is found within the central nervous system (CNS), referred to as the gamma-aminobutyric acid (GABA)-benzodiazepine receptor-chloride ion channel complex.[3] When benzodiazepines bind onto or near this macromolecular complex, they potentiate GABA-ergic synaptic inhibition through membrane hyperpolarization, thus enhancing the conductance of the chloride ion by increasing the frequency of channel-opening events.[3] The net result is the reduction of anxiety and related symptoms via the diminution of neurotransmission (i.e., neuronal firing) among many brain regions, such as the spinal cord, hypothalamus, hippocampus, substantia nigra, cerebellar cortex, and cerebral cortex.[3]

Table 6: Commonly Prescribed Benzodiazepines

Name	Half-life (hours)	Dosage Range (per day)	Initial Dosage (per day)
Alprazolam (Xanax)	14	1 to 4 mg	0.25 to 0.5 mg four times daily
Chlordiazepoxide (Librium)	20	15 to 40 mg	5 to 10 mg three times daily
Clonazepam (Klonopin)	50	0.5 to 4.0 mg	0.5 to 1.0 mg twice daily
Clorazepate (Tranxene)	60	15 to 60 mg	7.5 to 15 mg twice daily
Diazepam (Valium)	40	6 to 40 mg	2 to 5 mg three times daily
Lorazepam (Ativan)	14	1 to 6 mg	0.5 to 1.0 mg three times daily
Oxazepam (Serax)	9	30 to 90 mg	15 to 30 mg three times daily

(Adapted from: Gliatto MF. Generalized anxiety disorder. Am Fam Physician 2000;62:1591-1600, 1602).

All the benzodiazepines have similar efficacy. They lower anxiety by reducing the somatic symptoms and hyper-vigilance associated with anxiety.[2] Benzodiazepines with a short half-life can be used on an "as needed" basis by elderly patients and in patients with liver disease.[2] The shorter-acting agents, such as alprazolam, diazepam, and lorazepam, are rapidly absorbed and have a greater tendency to be abused.[4]

When abuse of benzodiazepines does occur, it often occurs in conjunction with other drugs, such as the opiates.[5] Patients with a prior history of alcohol or drug abuse and those having a personality disorder are more likely to abuse the benzodiazepines.[6] Younger patients who do not have other medical conditions can use the benzodiazepines with a longer half-life. These longer-acting agents have several advantages over the shorter-acting ones since they can be taken less often throughout the day; they produce less anxiety between doses and they produce less severe withdrawal symptoms when the medications are discontinued.[2]

Dependence and Side Effects

The major concern with the benzodiazepines is that dependence can develop from chronic use. Dependence refers to the withdrawal symptoms that occur once the benzodiazepines are discontinued. These include anxiety, irritability, and insomnia. These withdrawal symptoms usually abate within 48 to 72 hours, but it is not uncommon for patients to eventually return to their pre-treatment state of anxiety (referred to as recurrent anxiety).[6] It is more preferable to view any dependence to benzodiazepines as the result of a pharmacological adaptation.

Pharmacological dependence should be seen as an expected and natural adaptation of a body system long habituated to the presence of a drug, which can be effectively managed by dose tapering, medication switching, and/or medication augmentation.[7] The real problems have to do with the discontinuation side effects that can occur long after stopping the benzodiazepines. In one study, 20 participants who had withdrawn from medication (mean 42 months) had impairments in verbal memory, motor control/performance, and nonverbal memory when assessed by a battery of neuropsychological tests.[8]

Therefore, the most concerning issues with the benzodiazepines are the chronic use problems that occur when patients stop these medications due to

recurrent anxiety, and/or the long-term cognitive impairments that can persist many months after discontinuation. Addiction and abuses are uncommon complications when the benzodiazepines are used properly. Other types of problems associated with chronic use of benzodiazepines have to do with their ability to dampen feelings and emotions. It is not uncommon for patients to seem less "human" when chronically on these medications. Although the benzodiazepines have a dramatic ability to reduce anxiety, they seem to have an equal ability to blunt emotions and dampen responses to everyday events. A patient may report that his anxiety is pretty much gone, but the patient's friend, wife, or partner will probably indicate that something discernible has happened to the patient. They don't get as happy or sad as they used to, and they seem somewhat detached from reality. This information was not obtained from textbooks or scientific articles; rather, it is my observation after treating hundreds of anxiety patients during 7 years of clinical practice. I can recall only one patient who did not display a dampened affect from the chronic daily use of a benzodiazepine.

Other Medications

Other medication options for anxiety patients include buspirone (BuSpar), selective serotonin reuptake inhibitors (SSRIs), and tricyclic antidepressants (TCAs). Buspirone is a serotonergic (5HT-1) agonist that is useful for patients who suffer recurrent anxiety upon discontinuation of benzodiazepines and for patients with a prior history of alcohol abuse.[9] Buspirone is comparable in terms of efficacy to the benzodiazepines for the treatment of generalized anxiety disorder,[10] but it does not result in any physical dependence or tolerance.[11] Although buspirone is effective in alleviating the worry associated with anxiety, it does not have a fast onset like the benzodiazepines, and it may take 2 to 3 weeks to have a therapeutic effect.[5] The typical therapeutic dose is 20 to 30 mg per day. Common side effects include nervousness, insomnia, weakness, dizziness, paresthesia, nausea, and diarrhea.[12]

Antidepressants, such as SSRIs and TCAs, have similar efficacy at reducing anxiety attacks and improving functioning.[1] These medications modulate several neurotransmitter systems (serotonin and/or norepinephrine) implicated in anxiety.[13] They can be given to patients who have not responded to benzodiazepine therapy or buspirone. These medications, the usual starting doses, typical therapeutic doses, and important

side effects are listed in Table 7.[12] Since each class of medication has its own set of side effects, patients' adherence is mainly dependent on their tolerance to these drugs. Patients should take the antidepressants for 6 months after they become free of anxiety. Once the 6 months have elapsed, the medications can be withdrawn, though patients should continue to be monitored for a return of anxiety symptoms.[14]

Table 7: Commonly Prescribed SSRIs and TCAs for Anxiety Disorders

Name	Usual Starting Dose*	Typical Therapeutic Dose*	Important Side Effects
SSRIs and newer agents			
Fluoxetine (Prozac)	10 mg daily a.m.	20-80 mg/day	Somnolence, agitation, sweating, nausea, anorexia, and sexual dysfunction
Paroxetine (Paxil)	10 mg daily	20-50 mg/day	
Sertraline (Zoloft)	25 mg daily	50-200 mg/day	
Fluvoxamine (Luvox)	25 mg bedtime	50- 300 mg/day	
Nefazodone (Serzone)	50 mg daily	150-300 mg/day	
Venlafaxine (Effexor)	18.75-25 mg daily	75-150 mg/day	
TCAs			
Imipramine (Tofranil)	10 mg bedtime	100-200 mg/day	Anticholinergic: dry mouth, constipation, blurred vision, orthostatic hypotension, weight gain, and somnolence
Desipramine (Norpramin)	10 mg bedtime	100-200 mg/day	
Amitriptyline (Elavil)	10 mg bedtime	100-200 mg/day	
Nortriptyline (Pamelor)	10 mg bedtime	50-100 mg day	

*Patients who are elderly and/or have severe diseases should be given one-half the dose listed.

(Adapted from: Uphold CR, Graham MV. Anxiety Disorders. Clinical Guidelines in Family Practice. 3rd ed. Gainesville, FL: Barmarrae Books, 1998:112.)

Effectiveness

The medical approach is effective for mitigating symptoms of anxiety. Medications work well and can significantly reduce the somatic and/or emotional symptoms of anxiety. Medicating patients during an acute crisis is often important and potentially lifesaving.

However, after the short-term, patients should be weaned off these medications and started on an orthomolecular approach (if not already instituted). In the next chapter, the orthomolecular approach to diagnosis will be reviewed, followed in subsequent chapters with a discussion of orthomolecular treatments (including niacinamide, inositol, and removal of cerebral allergies).

References

1. Ham P, Waters DB, Oliver MN. Treatment of panic disorder. Am Fam Physician 2005;71:733-39, 740.

2. Gliatto MF. Generalized anxiety disorder. Am Fam Physician 2000;62:1591-1600, 1602.

3. Trevor AJ, Way WL. Sedative-hypnotic drugs. In Katzung BG (ed.). Basic & Clinical Pharmacology. 6th ed. Norwalk, CT: Appleton & Lange, 1995:338-39.

4. Schweizer E. Generalized anxiety disorder. Longitudinal course and pharmacologic treatment. Psychiatr Clin North Am 1995;18:843-57.

5. Longo LP. Non-benzodiazepine pharmacotherapy of anxiety and panic in substance abusing patients. Psychiatr Annals 1998;28:142-53.

6. Schatzberg AF, Cole JO, DeBattista C. Manual of Clinical Psychopharmacology. 3rd ed. Washington, DC: American Psychiatric Press, Inc., 1997.

7. O'brien CP. Benzodiazepine use, abuse, and dependence. J Clin Psychiatry 2005;66 (Suppl 2):28-33.

8. Barker MJ, Greenwood KM, Jackson M, et al. An evaluation of persisting cognitive effects after withdrawal from long-term benzodiazepine use. J Int Neuropsychol Soc 2005;11:281-89.

9. Rickels K, Schweizer E. The clinical course and long-term management of generalized anxiety disorder. J Clin Psychopharmacol 1990;10:101S-110S.

10. Goa KL, Ward A. Buspirone. A preliminary review of its pharmacological properties and therapeutic efficacy as an anxiolytic. Drugs 1986;32:114-29.

11. Schweizer E, Rickels K. Strategies for treatment of generalized anxiety in the primary care setting. J Clin Psychiatry 1997;58(suppl 3):27-33.

12. Uphold CR, Graham MV. Anxiety Disorders. Clinical Guidelines in Family Practice. 3rd ed. Gainesville, FL: Barmarrae Books, 1998:106-113.

13. Connor KM, Davidson JR. Generalized anxiety disorder: Neurobiological and pharmacotherapeutic perspectives. Biol Psychiatry 1998;44:1286-94.

14. Mavissakalian MR, Perel JM. Duration of imipramine therapy and relapse in panic disorder with agoraphobia. J Clin Psychopharmacol 2002;22:294-99.

ORTHOMOLECULAR DIAGNOSIS OF ANXIETY DISORDERS

④

Similar to the medical diagnosis of anxiety disorders, the orthomolecular work-up requires that possible organic (pathological) causes of anxiety be ruled out first. Once organic causes have been ruled out, patients are given a thorough medical history and physical exam, with their mental status evaluated for the presence of anxiety symptoms.

Mainstream medicine considers that the majority of anxiety sufferers are unwell because of a functional disturbance, but this does not involve an organic cause. Orthomolecular medicine also considers anxiety a functional problem, but goes one step further by elucidating plausible causes. From the orthomolecular perspective, anxiety results from the perturbation of brain function due to nutrient deficiencies, nutrient dependencies, cerebral allergies, and/or hypoglycemia.

Mental State

According to A. Hoffer, the most efficient method of assessing the mental status of patients is to use Karl Menninger's four main characteristics of the mental state as a guide, as described in Table 8.[1]

Table 8: Menninger's Four Main Characteristics of the Mental State

1. **Perception:** Illusions and hallucinations, visual, auditory, taste, smell, and touch.
2. **Thought:** Content and process. Process refers to the ability to construct logical sentences and to speak in an intelligible manner. Content refers to what is being thought or discussed. Both content and process can be disordered. Content disorders include paranoid ideas and ideas of references, as well as mutism and blocking (where ideas disappear from the mind), too rapid speech, disorganized speech, and so on.
3. **Mood:** Anxiety, manic, hypomanic, normal, mildly depressed, and severely depressed. Mood can also be flat and inappropriate.
4. **Behavior:** Can be classified as appropriate or not appropriate. In other words, is the patient behaving in a manner that is socially acceptable or not? The patient's behavior may be too fast (agitated) or too slow (sluggish). This category is the result of the interplay of the three preceding categories.

If anxiety symptoms predominate in the absence of perceptual, thought, or behavioral disturbances, the clinician should inform the patient that they have a primary diagnosis of anxiety. If the patient has anxiety and also has problems with perception and thought, the patient may have a primary diagnosis of schizophrenia with concomitant anxiety.

Menninger's classification simplifies the evaluation of a patient's mental state and allows any novice or experienced clinician to pinpoint the patient's mental dysfunction comfortably. In addition, to the assessment of the patient's mental state, it is a good idea to assess the severity of anxiety by using a validated rating scale, such as the Beck Anxiety

Inventory (BAI) or the Hamilton Anxiety Rating Scale (HAM-A). These rating scales take less than five minutes for patients to fill out, and provide a score. The higher the score, the more severe the anxiety, which is commonly rated as mild, moderate, or severe. Rating scales should be repeated after a period of time to assess if the patient's score has improved from its baseline. These rating scales can be found on the Internet.

Causal Factors

In orthomolecular medicine, once a psychiatric problem has been identified, a more definitive causative diagnosis should still be sought. Anxiety is really a label given to explain a constellation of symptoms, but has little value in determining the cause of a patient's anxiety. For example, a diagnosis of anxiety does not explain why this condition is affecting the patient.

Orthomolecular medicine does not just consider the mainstream organic causes of anxiety, but also attempts to identify other causal factors of anxiety, such as nutrient deficiencies, nutrient dependencies, cerebral allergies, and hypoglycemia. Each of these causal factors, alone or in combination, can cause dysfunction to the brain, thereby altering mood and resulting in the expression of anxiety.

Nutrient Deficiencies and Dependencies

A nutrient deficiency occurs when the minimal necessary amounts of a nutrient are not obtained due to an inadequate diet. If the minimal amounts are not met, within a short period of time (usually, a few months) the tissues will become depleted of the particular nutrient; biochemical abnormalities will occur and clinical features of the deficiency will be apparent by mental and/or physical changes. Based on this definition, any nutrient deficiency could cause mental status changes, such as anxiety. The solution would be to ensure that the diet is modified or fortified to restore adequate amounts of the deficient nutrient.

By contrast, a nutrient dependency denotes an increased metabolic need for a particular nutrient beyond the amount normally obtained through diet.[2] The cause of a nutrient dependency probably stems from long-term environmental-genetic stresses that impair biochemical processes dependent

upon a constant supply of the nutrient. Individuals with a nutrient dependency obtain the minimal amounts necessary to prevent a frank deficiency. Corrective treatment requires the intake of optimal amounts (optidoses) of the nutrient in order to normalize the underlying metabolic dysfunction. These doses need to be greater than could normally be obtained through diet alone.

Individuals having a nutrient dependency will likely have disturbances in mood (e.g., anxiety and depression) and somatic complaints (e.g., muscle pain and gastrointestinal complaints). The only way to confirm a clinical suspicion of a nutrient dependency is to provide optimal doses of the nutrient and see if the clinical problems improve or resolve.

In the next few chapters on orthomolecular treatments, nutrient deficiencies will not be specifically addressed since many authors in numerous texts and journal articles have reported on the clinical manifestations and treatments of nutritional deficiencies. In terms of nutrient dependencies, though, I will demonstrate that many causes of anxiety are probably the result of nutrient dependencies to vitamins, specifically vitamin B-3 (niacin or niacinamide), B-12 (cobalamin), and other B vitamins, as well as inositol, specific amino acids, minerals (calcium and magnesium), or omega-3 essential fatty acids.

Associated Cerebral Allergies

Foods and other substances have the capability of causing anxiety and other neuropsychiatric signs and symptoms. Reports in the scientific literature describe such association as cerebral allergies.[3,4] "Cerebral allergy," R. Whalen writes, "is an allergy to a substance which targets vulnerable brain tissue and alters brain function."[5]

Perhaps the best way of explaining this relationship is to view cerebral allergies as an ecologically-induced mental illness. In defining ecologic mental illness, M. Mandell states: "The human brain may be viewed as a complex allergic shock tissue which is easily reached by inhaled and ingested excitants from the environment via its rich blood supply. No physician can render adequate care to any sick individual unless he acquires a thorough knowledge of ecologic disease."[6]

There are two distinct mechanisms by which cerebral allergies can cause disturbances in brain function. The first mechanism involves the

direct pharmacological effects of substances or chemicals found in foods or beverages. The main culprits within this category are caffeine, alcohol, and sugar (glucose). The second mechanism involves masked, hidden, or delayed cerebral allergic responses to foods or beverages. These include wheat, milk, egg, and corn allergies.

Thus, the human brain is vulnerable to insults from the environment, whether from inhaled or ingested sources. Different types of foods and inhaled factors have been implicated in producing anxiety. Water fast, hypoallergenic diets, and avoidance of specific foods have been found to be therapeutic.

Associated Hypoglycemia

Low blood sugar (glucose) is the lay term for hypoglycemia, which is best described as "an abnormality of metabolism that results in a precipitous drop or a flat curve in normal blood sugar levels."[7] Just like nutritional deficiencies/dependencies and cerebral allergies, hypoglycemia can cause anxiety.

Common psychological symptoms of hypoglycemia include fatigue, irritability, nervousness, depression and crying spells, vertigo or dizziness, faintness, insomnia, mental confusion or forgetfulness, inability to concentrate, anxiety, phobias and fears, disperceptions, disruptive outbursts, and headaches.[8] Hypoglycemia should be considered when these psychological symptoms occur after fasting, late at night, first thing in the morning, or when it is somehow related to a meal or to the content of a meal.[8]

We are all equipped to deal with transient episodes of low blood glucose on an occasional basis. It is customary for these regulatory mechanisms to go into full force when a meal is missed or delayed, when too many sweets are consumed, when exercise is overdone, or when we experience temporary vitamin and mineral deficiencies.

Even though the body has many overlapping mechanisms to guard against hypoglycemia, the patient struggling with anxiety is probably putting added stress on these systems. The typical anxiety patient has probably been eating poorly for months or years, has a variety of nutrient dependencies, and is unaware that his episodes of anxiety and/or panic are related to diet, metabolic stress, and episodes of hypoglycemia.

Refined foods and sweets tend to be the cornerstones of the anxiety patient's diet. This leads to a chronic state of inadequate nutrition, over-whelmed blood glucose regulatory systems, and an inability to cope.

The end result is poor blood glucose regulation, leading to eating behaviors that serve to potentiate this dysfunctional process, more stress on glucose regulatory systems, and numerous bouts of anxiety and/or panic attacks.

References

1. Hoffer A. Diagnosing schizophrenia: Past, present and future. *J Orthomol Med* 1999;14:3-15.

2. Hoffer A. Vitamin B-3 dependency: Chronic pellagra. *Townsend Lett Doctors Patients* 2000;207:66-73.

3. Schaubschlaeger WW, Schiaak M. Pseudoallergic reactions due to food and food additives. *Int Clin Nut Rev* 1989;9:128-136.

4. Whitford T. The underlying mechanisms of brain allergies. *J Orthomol Med* 2000;15:5-14.

5. Whalen R. Caffeine anaphylaxis: A progressive toxic dementia. *J Orthomol Med* 2003;18:25-28.

6. Mandall M. Cerebral reactions in allergic patients. Illustrative case histories and comments. In Williams RJ, Kalita DK (eds.). A Physicians' Handbook on Orthomolecular Medicine. New Canaan, CT: Keats Publishing, Inc., 1977:130-39.

7. Currier W, Baron J, Kalita DK. Hypoglycemia: The end of your sweet life. In Williams RJ, Kalita DK (eds.). A Physicians' Handbook on Orthomolecular Medicine. New Canaan, CT: Keats Publishing, Inc., 1977:156-60.

8. Pfeiffer CC. Hypoglycemia – the sugar blues. *Nutrition and Mental Illness.* Rochester, NY: Healing Arts Press, 1987:57-65.

TREATING ANXIETY WITH VITAMIN B-3 (NIACINAMIDE)

Niacin and niacinamide are both commonly referred to as vitamin B-3. The biochemistry of vitamin B-3 is well known in that it is involved in 200 enzymatic reactions, mostly involving dehydrogenases within the human body. Its active forms or its coenzymes are both nicotinamide adenine dinucleotide (NAD) and nicotinamide adenine dinucleotide phosphate (NADP). Vitamin B-3 can be absorbed directly from the stomach, but most of its absorption occurs within the small intestine. The liver contains the most concentrated amounts of the nicotinamide coenzymes, but all metabolically active tissues require these vital metabolic products.

Pellagra

The most common use of nicotinamide and niacin is for the treatment of pellagra. Pellagra is a disease caused by a cellular deficiency of the nicotinamide coenzymes due to inadequate dietary supply of tryptophan and vitamin B-3 (as either niacin or nicotinamide). Diarrhea, dermatitis, and

dementia characterize this deficiency disease. Although is it not usually fatal, death can occur when these three Ds are present.

The adult intake of vitamin B-3 necessary to prevent pellagra is around 20 mg per day. The body can manufacture approximately 1 mg of niacin equivalents from 60 mg of tryptophan obtained mostly from dietary protein sources. This *in vivo* conversion makes it difficult to develop frank pellagra in affluent, industrialized countries. Rare forms of pellagra do occur. Pellagra has been found among patients with anorexia nervosa,[1] hypothyroidism,[2,3] and alcoholism,[4,5] as well as among homeless men[6] and among some patients taking anticonvulsant medications.[7,8]

Anxiety

Every day in my practice, I evaluate and treat patients suffering from unremitting anxiety symptoms. In my efforts to mitigate their anxiety, I have been prescribing the amide of niacin (nicotinic acid), known as niacinamide (nicotinamide).

Here, I report on four cases where the optimal doses of nicotinamide considerably improved the symptoms of anxiety.[9,10] In each of these cases, frank symptoms of pellagra were absent, even though neuropsychiatric and gastrointestinal manifestations were present.

These four case reports demonstrate that niacinamide is capable of reducing symptoms of anxiety. All four patients responded favorably to optimal doses of niacinamide (2000 to 2500 mg per day or as needed). These amounts were much greater than the amounts of vitamin B-3 or protein (containing tryptophan) that would be necessary to prevent full-blown pellagra.

Case #1: Physician with a History of Severe Anxiety

A 33-year-old Caucasian male presented with a history of anxiety for the past 20 years. When the patient was 13, his homeroom teacher would embarrass him every week by having him stand up in front of the class and remain standing until he was noticeably red in the face, at which point the teacher would comment about how red he was. The entire class would laugh at this. Over time, this patient became increasingly nervous and fearful about social situations and involvement in activities that could

draw attention to him. Throughout junior high and high school, the patient would have pronounced anxiety and panic when making presentations and conversing with his peers, friends, or girls. Typically, his symptoms were facial flushing, profuse sweating, increased heart rate, muscle tension, burning in the stomach, and the need to get away.

These symptoms persisted throughout university, and when the patient was 22, he finally sought professional help for his anxiety. The clinical psychologist diagnosed the patient with social phobia, panic disorder, and mild agoraphobia. The patient underwent once- or twice-weekly sessions of psychodynamic and cognitive-behavioral therapy for the next 6 months. During this time, the patient's symptoms improved only slightly, but the patient somehow convinced the psychologist that he was completely cured and that therapy was no longer necessary.

By the time he was 24 years old, he entered medical school and his anxiety worsened. He was so upset by his inability to just "go with the flow," or "feel comfortable in my own skin" that he again sought the help of a psychiatrist. This time the psychiatrist assessed and diagnosed him with social phobia, panic disorder, dysthymia, and mild agoraphobia. He was started on Zoloft (sertraline HCl) 50 mg daily. After the first 2 weeks, the patient's anxiety slightly improved, but he had noticeable side effects from the medication, such as lethargy, apathy, and anorgasmia. After 4 weeks of use, the Zoloft seemed to work fairly well; the patient had some days without any anxiety. His dose of Zoloft was increased to 100 mg daily. The patient was also put on 5 mg of Buspirone (BuSpar) three times each day. After 3 months of use, the patient had no significant improvement, and his anxiety symptoms continued to be debilitating. He found his tendency to avoid social situations increased due to severe fears of blushing. He also avoided interactions with his professors and peers as much as possible. He preferred to stay at home and only go out when necessary. At this point he discontinued both the Zoloft and BuSpar due to their apparent ineffectiveness.

From age 25 to 28, the patient investigated a variety of natural approaches for the treatment of his anxiety. From his readings, he decided to take the following nutrients daily: 6 to 12 g of vitamin C; 800 IU of vitamin E; 50 mg of zinc; a B-complex containing 100 mg of each of the B vitamins; 1000 mg of calcium; and 400 mg of magnesium. Although he

followed this plan diligently, his anxiety did not lessen. After 6 months of the vitamin plan, he added a standardized extract of Kava two to three times each day. Within 2 weeks, his anxiety symptoms were markedly improved. He was able to be in stressful social situations without blushing or appearing nervous.

However, by the fourth week of continual Kava use, he experienced pronounced depression. The depression became so unbearable that he felt it necessary to discontinue the Kava. After a few days of discontinuing the Kava, the patient's depression completely lifted. In an attempt to see if the Kava was the problem, the patient resumed taking Kava. Once again, the anxiety significantly improved, but his depression came back. He discontinued the Kava, and shortly thereafter the depression lifted once again. By the time the patient was 28, he had also tried St. John's wort, adrenal extract, constitutional homeopathic medicine, and amino acids, such a gamma-aminobutyric acid (GABA), inositol, and L-taurine. None of these natural approaches helped.

Just before he turned 29, the patient's anxiety worsened. Even though he did not notice any reduction in anxiety, he continued to take the following nutrients daily: 6 to 12 g of vitamin C; 800 IU of vitamin E; 50 mg of zinc; a B-complex containing 100 mg of each of the B vitamins; 1000 mg of calcium; and 400 mg of magnesium. During his medical residency, he purposely avoided his assigned patients, his condition significantly interfering with his ability to perform. Due to the urgency that he felt, he once again sought the help from a medical doctor, who prescribed 0.5 mg of Ativan (lorazepam) twice daily. Within 2 days, all of his anxiety symptoms resolved and the patient felt normal for the first time in his life. He could function and perform with confidence. His anxiety did not interfere or prevent him from completing the residency program.

From ages 29 to 33, the patient continued with the benzodiazepine medication. At one point, his medical doctor changed the Ativan to Klonopin (clonazepam, 0.5 mg twice daily) since he was told that this preparation was better for long-term use. He had no more anxiety symptoms, but never felt good about taking the benzodiazepine medication. When he was 32, he went off the Klonopin for 1 month. During the first week, he experienced severe insomnia at night, and during the day, he experienced recurrent bouts of panic and anxiety. Almost 2 weeks later,

the insomnia resolved, but his anxiety returned to its pre-treatment state. He was completely debilitated. He resumed the Klonopin and once again felt complete relief.

When he turned 33, he did somewhat of a literature search on anxiety and found intriguing information on niacinamide. He informed his psychiatrist of his plan to wean himself off the Klonopin and take niacinamide. The psychiatrist encouraged the patient to do so, but wanted the patient to contact him if he were to experience withdrawal symptoms, such as recurrent anxiety, insomnia, and irritability. For the first week, the patient took 0.5 mg of Klonopin every morning along with 500 mg of niacinamide, 500 mg of niacinamide at lunch, and 1000 mg at bedtime. He experienced no recurrences of his anxiety or insomnia during the first week of weaning. In the second week, the patient discontinued the Klonopin and took 1000 mg of niacinamide in the morning, 500 mg at lunch, and 1000 mg at bedtime. The patient felt great and could not distinguish between taking Klonopin and niacinamide. The patient was completely free of benzodiazepine medication as of August 1, 2002. The psychiatrist was impressed with the outcome and commented that it gave him hope that a patient could actually go off benzodiazepine medications and not chronically depend on them.

As of November 7, 2003, this 33-year-old patient has been able to practice as a doctor without any impairments or restrictions, and continues to do very well approximately 15 months after stopping the Klonopin. He no longer feels that anxiety is a problem, and believes that the niacinamide is equally as effective as benzodiazepine medication, but is potentially safer to take for long-term use.

Case #2: Girl with Panic Disorder and Social Phobia

An 11-year-old girl first presented to my office on November 10, 2003. Her chief complaints were nervousness, anxiety, and excessive worrying. The onset of her symptoms occurred when her father tragically died in September 2003.

She reported anxiety when she had to sit for examinations and when she was around her classmates. The most concerning symptom was her fear of being kidnapped, which was instigated by a well-publicized kidnapping of a young Asian girl in the city where she lives. She also reported

having approximately two panic attacks each month since September. She had learned to deal with them by "leaving the situation to get air." Other symptoms that were reported included some facial acne, frequent blushing, stomachaches, and sweatiness. Her past medical history was unremarkable, except for asthma that was diagnosed approximately 1 year ago. The asthma was not a concern since her symptoms were reported to be mild with the rare use of an inhaler as needed. Apart from the inhaler, she was on no other medications at the time of the visit.

A complete physical examination was performed, and all findings were within normal limits. The only notable sign was some acne along her cheeks and chin. She was diagnosed with PD, with some elements of social phobia. She was prescribed a daily multiple vitamin/mineral preparation, 25 mg of zinc, 100 mg of pyridoxine, 400 mg of magnesium, and 500 mg of niacinamide twice daily.

A follow-up appointment occurred on December 13, 2003. The patient reported a slight improvement with her anxiety. She did not like taking all the supplements and agreed to continue with just the multiple vitamin/mineral preparation, zinc, and niacinamide. She also agreed to increase the dose of niacinamide to 1000 mg twice daily. No side effects were reported.

A second follow-up occurred on February 7, 2004. The patient, now 12-years-old, reported a striking improvement with her anxiety. She did not always take her pills daily, but was happy with the results. Her panic attacks completely stopped, and her acne was much improved as well.

In a recent e-mail from the patient, she reported to be taking only the 1000 mg of niacinamide twice daily. Her anxiety remained much improved and was no longer interfering with her ability to engage in a regular life.

Case #3: Woman with Generalized Anxiety Disorder

A 28-year-old woman came to my private practice with a chief complaint of GAD on May 10, 2004. She had been struggling with this anxiety disorder for the past 12 years. She is a high-school teacher, and noted that her anxiety was more pronounced during the academic year. Her anxiety was worse in the morning, with symptoms of frequent muscular tension, the passing of flatus, and chest pain. She reported a fear of smelling bad when

she needed to expel gas. The anxiety also made it difficult for her to concentrate and focus on things.

When she experienced anxiety symptoms, she would feel the need to isolate herself from others. The same isolating need would also occur when she simply thought about possibly feeling nervous and expelling gas. She also reported fears of embarrassment and worried about being criticized from others. She had been on paroxetine for 1 year, but had not noticed any improvement. She reported feeling depressed due to the anxiety and would get apathetic when her anxiety was at its worst. Baths, lying in bed, walking, and exercising helped to reduce her anxiety slightly. She was unable to correlate any of her symptoms with foods. This patient also had a history of thrombocytopenia for the past 5 years, for which she was being regularly monitored by her family physician. She did report easy bruising, but did not have any history of widespread bruising and bleeding. The rest of her past medical history was insignificant.

Physical examination revealed a well-nourished woman with normal vital signs. All her systems were within normal limits. She was subsequently diagnosed with GAD (with some social phobia) and thrombocytopenia. Lab tests were requisitioned, and she was prescribed niacinamide at an initial dose of 500 mg three times daily for 3 days, and then was instructed to increase it to 1000 mg every morning, 500 mg at lunch, and 1000 mg at dinner. She was also prescribed 5-hydroxytryptophan (5-HTP) at a dose of 100 mg twice daily for her mild depression, and 2000 mg of vitamin C to be taken daily for the thrombocytopenia.

The patient had a follow-up appointment on May 31, 2004. She had difficulty swallowing the niacinamide pills due to their bitter taste. Despite this, she was taking the recommended dose of 2500 mg per day. Her anxiety was much improved and she had experienced only three minor panic attacks since the initial visit. Prior to the treatment, her anxiety was chronic, occurring daily, with the sensation or need to pass gas. The patient continued to complain of depression, which she felt was more pronounced prior to menses. Her complete blood count was normal, except that her platelets were low at a value of 79 (reference range, 150-400 X 10^9/L). The patient was unsure if the treatments were working due to her time away from teaching. We agreed that she would discontinue all prescribed treatments, except for the vitamin C, until June 14, 2004. After

this date, the patient would resume the 5-HTP and niacinamide, take 250 mg of vitamin B-6 and 400 mg of magnesium. The vitamin B-6 and magnesium were prescribed for the premenstrual symptoms of depression.

On June 4, 2004, I received an urgent telephone call from the patient. Since discontinuing the prescribed treatments on June 1, her anxiety symptoms returned promptly and she had difficulty functioning. She agreed to resume only the niacinamide tablets.

On July 2, 2004 the patient e-mailed me with an update. She had discontinued all the prescribed treatments, except for the niacinamide. She found her anxiety and depression to be much relieved due to being at home and not teaching during the summer months. When she felt anxiety, she would take niacinamide and it would help. In her words, "I take the niacinamide and I'm fine afterwards."

Case #4: Woman with Panic Attacks

A 42-year-old woman first presented to my private practice on May 16, 2004, for chief complaints of constipation and anxiety. About 3 weeks before, her father was diagnosed with advanced carcinoma of the stomach. For 3 days following his diagnosis, the patient experienced very soft stools once or twice daily. For her entire life, she had been constipated, requiring regular laxatives in order to have a daily bowel movement. The patient reported additional gastrointestinal symptoms of bloating, gas, and right-sided abdominal pain. She had taken fiber therapy in the past, but had never stayed on it long enough to see the benefits. She was not concerned about the constipation since she had been having at least one-to-two soft stools per day.

Since her father's diagnosis, she had been feeling very anxious with symptoms of shakiness, light-headedness, numbness of the extremities, and balance problems. Her medical doctor had her do a 24-hour Holter monitor and the results were normal. She was unable to correlate her anxiety with feelings of hunger. In the past, she would have the same kind of anxiety symptoms when stressful events occurred. Her medical doctor felt that the patient's anxiety was related to hyperventilation.

On physical examination, the patient was well-nourished but slightly overweight, with normal blood pressure and normal heart sounds. All other systems were within normal limits. Even though her mother currently has

heart disease, the rest of her family history was unremarkable. She was diagnosed with panic attacks, dyspepsia (possible irritable bowel syndrome), and mild obesity. She was advised to continue with her liquid multiple vitamin/mineral preparation, to take 500 mg of niacinamide three times each day for 2 days, and to increase the dose to 1000 mg twice daily. Two capsules of *Lactobacillus acidophilus* were prescribed every morning upon rising.

A follow-up visit occurred on May 26, 2004. The patient felt a little better during the first week on niacinamide. However, she felt jittery, and related this to her father's grim prognosis. Her sleep was unaffected, even though she did wake up once each night to go to the bathroom. Overall, she felt much more under control. She was advised to increase the niacinamide to 1000 mg three times each day.

On July 12, 2004, she came in for another visit. She had cut back on the niacinamide since she felt that it caused her to have feelings of not being "present." Instead of 3000 mg daily, she lowered the dose to 2000 mg per day. Her constipation was not a problem, and she was having one bowel movement daily. Her anxiety was much improved on this dose, and the previous shakiness had completely resolved. In fact, she had not experienced any episodes of shakiness since the last visit. She was told to continue the prescribed treatments and to take a B-complex vitamin preparation and 1 mg of folic acid each day.

Mechanism of Action

The therapeutic mechanism of action of nicotinamide treatment could relate to several factors:

- Correction of subclinical pellagra
- Correction of an underlying vitamin B-3 dependency disorder
- Benzodiazepine-like effects
- Ability to increase the production of serotonin
- Ability to modify the metabolism of blood lactate (lactic acid).

Even though niacinamide has multiple (theoretical) modes of action, I believe that the correction of a vitamin B-3 dependency is most likely responsible for its main therapeutic effects.

Subclinical Pellagra

The initial symptoms of pellagra tend to involve the gastrointestinal system, which are known to precede the dermatological ones.[11] In these four patients, the gastrointestinal symptoms formed part of their clinical presentation. It was impossible to determine if these symptoms preceded their anxieties or neuropsychiatric symptoms. In Case #4, the patient reported a long-standing history of constipation many years before the onset of acute anxiety. In the other three cases, the patients had anxiety symptoms with mild gastrointestinal manifestations. In Case #1, the patient had stomach burning as one of his anxiety symptoms. The patient in Case #2 had stomachaches when she felt anxious; and in Case #3, the patient passed gas when she experienced anxiety.

It appears that these patients had pellagra-like symptoms primarily involving the neuropsychiatric system. One of the earliest reports describing the psychological patterning of central nervous system impairments due to an inadequate supply of niacinamide came from the work of W. Kaufman.[12] He used the term "aniacinamidosis" to denote a deficiency state that could not be ameliorated by dietary modifications, but required between 150 to 350 mg of niacinamide each day to reverse its clinical manifestations. The psychological symptoms associated with aniacinamidosis are described in Table 9. Some of the symptoms listed in the table are similar to the symptoms exhibited by the patients in the four case reports.

Table 9: Adult Pattern of Psychological Symptoms in Aniacinamidosis

- Has not felt like "himself" for weeks or years
- Feels tense; can't relax
- Is impatient and irritable
- Frequently has unwarranted anxieties
- Worries about unimportant things and can't seem to shake worries
- Has the feeling of impending trouble
- Not sure of his knowledge or abilities
- Has uncertainties as to what the future will hold for him

- Has lost his former interest in work, family, friends
- Adjusts poorly to ordinary life situations
- Lacks initiative
- Not cooperative
- Routine duties have become particularly burdensome
- Delays making decisions
- Shuns and fears unfamiliar people, ideas, situations
- Frequently wishes to be alone, to get away from everyone
- Is unhappy, frequently without apparent cause
- Frequently thinks that something is seriously wrong with him
- Can't sleep right

In his study of subclinical pellagra, R.G. Green noted that mental symptoms occurred in patients without frank deficiency of vitamin B-3.[13] Similarly, A. Hoffer reported that the earliest symptoms of subclinical pellagra manifest as modern mood disorders (e.g., anxiety, depression, fatigue, and vague somatic complaints), followed by the development of other symptoms.[14] It is evident that subclinical pellagra can present with symptoms primarily affecting the neuropsychiatric system, but it has yet to be determined why this condition occurs in susceptible people.

One possible explanation might involve a phenomenon known as a localized cerebral deficiency disease. Linus Pauling discussed the possibility of having grossly diminished cerebrospinal fluid (CSF) concentrations of a vital substance while its concentration in the blood and lymph remain essentially normal.[15] This localized cerebral deficiency, according to Pauling, might occur from decreased rates of transfer (i.e., decreased permeability) of the vital substance across the blood-brain barrier, an increased rate of destruction of the vital substance within the CSF, or some other unknown factor.[15]

If the serum and CSF were examined for micronutrient status, perturbations between these compartments might demonstrate the presence of a localized cerebral deficiency. For example, in a study involving 49 patients with organic mental disorders, deficient CSF levels of vitamin B-12 (<5 pg/ml) were found in 30 of the patients.[16] When the serum levels of

vitamin B-12 were tested, normal values (200 to 800 pg/ml) were found in 45 of them, indicating a marked difference between both compartments. Given that serum levels of vitamin B-12 can be normal yet deficient in the CSF, other micronutrients (such as vitamin B-3) might follow a similar pattern of deficiency if the CSF and serum were analyzed.

The correction of subclinical pellagra might be one reason for niacinamide's effectiveness. We need to understand the role of localized cerebral deficiency of niacinamide, including niacinamide's metabolism within the CSF, before this diagnosis can be confirmed.

Enzymatic Defects

The positive responses to niacinamide suggest that this vitamin probably corrected an underlying vitamin B-3 dependency disorder. A vitamin B-3 dependency denotes an increased metabolic need for the vitamin. In order to sustain adequate health, it would be necessary to obtain a daily intake of vitamin B-3 in amounts greater than from dietary sources alone.[17]

Many enzyme systems within the body require optimal doses of vitamins to remedy defects in the synthesis of vital metabolic products to sustain adequate health. Linus Pauling believed that "mental disease is for the most part caused by abnormal reaction rates, as determined by genetic constitution and diet, and by abnormal molecular concentrations of essential substances."[15] He described how megavitamin therapy would be necessary for the optimal treatment of mental disease because the saturating capacity would be much greater for defective enzymes that have diminished combining capacity for their respective substrates. In other words, an enzyme-catalyzed reaction could be corrected by increasing the concentration of its substrate through the use of optimal doses of micronutrients.

In a study examining the possibility of vitamin B-3 dependency, two schizophrenic groups (n=58) were given 1.22 g of niacinamide and had their urinary excretion measured for 6 hours immediately after taking the nutrient orally.[18] All the schizophrenic subjects had a 2-hour baseline collection of urine before the niacinamide was administered. The schizophrenic subjects were compared to three control groups (n=77), and all subjects had their excretion rates of niacinamide subjected to statistical analysis. Subjects were considered to be in the "low excretor" category if

they had less than 6.4% of niacinamide in their urine 6 hours after taking the niacinamide. In the control groups, there were 32 low excretors (42%), compared to 45 in the schizophrenic group (78%). These results were statistically significant.

More subjects in the schizophrenic groups were low excretors than the subjects in the control groups. The schizophrenic subjects had an increased need for niacinamide, probably the result of some dysfunction of their enzyme systems. Thus, the schizophrenic subjects would require a greater intake of niacinamide if they were to have similar excretion rates to the control subjects. If anxiety patients were administered the same testing procedure and had their excretion rates of niacinamide compared to a group of controls, they might exhibit urinary excretion rates comparable to the schizophrenic subjects.

In a similar study, the urinary excretion of N^1-methylnicotinamide (a marker of vitamin B-3 status) was evaluated in four groups of patients: 38 healthy volunteers, 52 patients with secondary affective disorders, 55 patients with primary affective disorders, and 46 healthy first-degree relatives of the primary affective disorder patients.[19] The results demonstrated that the primary affective disorder patients and their first degree relatives had lower N^1-methylnicotinamide urine levels than the other groups ($P < 0.001$). The authors of this study speculated that low N^1-methylnicotinamide levels might be associated with a high morbidity risk among those with primary affective disorders.

Anxiety patients have some clinical features that are also present among primary affective disorder patients, such as depression, irritability, and sleep disturbances. Even though the N^1-methylnicotinamide excretion has not been formally tested in anxiety patients, this urine product may test low (indicating an increased need for the vitamin) and, if so, this might have some relationship to morbidity.

In a more recent report, the need for large doses of micronutrients were deemed necessary as a means to increase coenzyme concentrations and to correct defective enzymatic activity in 50 human genetic diseases.[20] The authors of this study went further by stating that the "examples discussed here are likely to represent only a small fraction of the total number of defective enzymes that would be responsive to therapeutic vitamins."

Likely, a good percentage of anxiety patients would respond to optimal doses of vitamin B-3 to correct both the disordered biochemistry and the resulting neuropsychiatric manifestations, particularly those which result from defective enzymatic activity.

Benzopidazepine-like Properties

Additional reasons for niacinamide's effectiveness may have to do with its benzodiazepine-like effects. In a review of the literature by A. Hoffer, both niacin and niacinamide were shown to have some sedative activity, and could potentiate the action of sedatives, anticonvulsant medications, and certain tranquilizers.[21] In a recent case report, I reviewed the literature to determine the biological mechanism for niacinamide's anxiolytic effects.[10] This data is summarized in Table 10.[22-27]

Table 10: Biochemical Data Summarizing Niacinamide's Benzodiazepine-like Effects

Reference	Results
22	Niacinamide modulated spinal cord activity, with anticonflict, anticonvulsant, muscle relaxing and hypnotic effects. The potency of niacinamide was found to be equivalent to a highly potent benzodiazepine. Niacinamide had a low affinity to the benzodiazepine-binding site in the mammalian brain. This low affinity may have been the result of the binding assay used, or it may have been a reflection that more than one binding site existed by which niacinamide exerted its benzodiazepine-like properties.
23	Niacinamide antagonized the effects of diazepam, therefore interacting with the benzodiazepine receptor *in vivo*. However, niacinamide did not mimic the benzodiazepine properties of diazepam when tested with the rat head-turning model. Niacinamide probably does have benzodiazepine-like properties at different benzodiazepine receptor sites in the CNS, but its effects are unrelated to the actions of gamma-aminobutyric acid (GABA).

24	Niacinamide had a qualitatively similar effect to that of diazepam. It was concluded that niacinamide exerted its effects by influencing the turnover of serotonin, noradrenaline (norepinephrine), dopamine, and GABA in those areas of the brain thought to be unbalanced in anxiety.
25	Niacinamide could be a competitive antagonist for the benzodiazepine receptor since it prevented the binding of kynurenine to the benzodiazepine receptor. It was further postulated that this action was more likely of central origin than peripheral origin. It could not be determined if niacinamide's action was indeed related to its occupation of the benzodiazepine receptor.
26	Niacinamide was structurally dissimilar to the benzodiazepine receptors. Niacinamide did not act as a specific ligand for the benzodiazepine receptor, but instead had a weak binding affinity for the receptor.
27	Niacinamide and its analogs possessed properties similar to benzodiazepines at various zones of the cerebral cortex by influencing the GABA-ergic system.

It appears that niacinamide has therapeutic effects comparable to the benzodiazepines. Its therapeutic effects are probably not related to it acting as a ligand for the benzodiazepine receptor, although it acts centrally and might have a weak binding affinity for the benzodiazepine receptor. Both the benzodiazepines and niacinamide exert similar anxiolytic effects through the modulation of neurotransmitters commonly unbalanced in anxiety.

Niacinamide might be helpful when weaning patients off their benzodiazepine medications. Benzodiazepine withdrawal symptoms include tinnitus, involuntary movements, paresthesias, perceptual changes, and confusion. Twenty-eight patients who had been abusing flunitrazepam for at least 6 months were abruptly taken off the drug.[28] The patients were randomly assigned to receive intravenous nicotinic acid (xantinol

nicotinate; 3 g in 1,500 ml of 10% glucose per day over the first 48 hours, followed by 1.5 g over the following 48 hours) or placebo (glucose solution alone). Although blinding was not specified, patients who received xantinol nicotinate had significantly fewer withdrawal symptoms than those who received placebo. These results suggest that intravenous administration of xantinol nicotinate can reduce withdrawal symptoms in patients discontinuing flunitrazepam. Even though intravenous xantinol nicotinate would achieve higher blood concentrations than oral niacinamide, both nutrients are forms of vitamin B-3, and, therefore, the parenteral and oral methods might similarly help to withdraw patients from their benzodiazepine medications. In Case #1, the patient was able to discontinue his Klonipin gradually without experiencing any withdrawal symptoms due to his optimal daily intake of niacinamide.

Serotonin Synthesis

Another biochemical reason for niacinamide's anxiolytic effects might have to do with the vital role that it has upon the synthesis of serotonin. For example, in a patient with anorexia nervosa, an insufficient supply of vitamin B-3 or protein resulted in reduced urinary levels of the serotonin breakdown product, 5-hydroxyindolacetic acid (5-HIAA).[29] The authors of this report postulated that a deficiency of vitamin B-3 reduced the feedback inhibition upon the kynurenine pathway, resulting in more tryptophan being diverted to the kynurenine pathway, making less substrate available for the synthesis of serotonin.

By contrast, the use of optimal doses of vitamin B-3 can increase the production of serotonin.[30] In a rat study, the administration of 20 mg of niacin resulted in increased levels of 5-HIAA and decreased levels of xanthurenic acid via the kynurenine pathway.[31] Taking optimal doses of niacinamide (or any other form of vitamin B-3) should increase the production of serotonin by diverting more tryptophan to become substrate for serotonin synthesis (Figure 1). Niacinamide's therapeutic ability to increase serotonin production might explain why it was successful in reducing the anxiety symptoms of the four patients.

Figure 1: Niacinamide's Therapeutic Effect upon Serotonin Synthesis

Supplemental niacinamide increases the conversion of dietary L-tryptophan to serotonin by inhibiting the enzyme, tryptophan oxygenase.

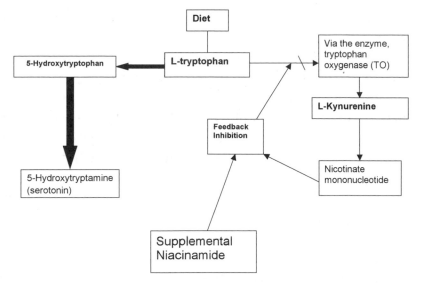

(Adapted from: Velling DA, Dodick DW, Muir JJ. Sustained release niacin for prevention of migraine headaches. Mayo Clin Proc 2003;78:770-771.)

Modulation of Blood Lactate (Lactic Acid)

The final biochemical reason for niacinamide's favorable effect might have to do with its ability to modulate the metabolism of blood lactate. Before this therapeutic mechanism is explained further, it is necessary to review some of the studies that have explored the relationship between lactic acid and anxiety. This research demonstrates a consistent link between PD and lactate provocation.

In a single-blind study using sodium lactate infusions, 11 out of 15 patients with PD had panic attacks with the lactate.[32] The 15 control subjects did not experience panic attacks during the infusions. Even though no biochemical abnormalities were seen between the groups, it was hypothesized that the treatment group had an increased baseline arousal level causing them to be more susceptible to panic attacks. In another

study, 72% of the treatment group (n=43) developed panic attacks with intravenous sodium lactate infusions.[33] The treatment group was composed of patients with either PD or agoraphobia with panic attacks. In the control group (n=20), none of the participants developed panic attacks with the infusions. There was increased activity of the central noradrenergic system in most of the patients in the treatment group who experienced panic attacks.

In a similar study, 43 subjects having PD or agoraphobia with panic attacks were administered infusions of sodium lactate.[34] Thirty-one of the subjects panicked in response to the infusions, whereas none of the 20 subjects in the control group had any panic attacks. It was concluded that the lactate-induced panic attacks were associated with heightened central noradrenergic activity and hyperventilation. It appears that the lactate-induced panic response involves angiotensin-II, which interfaces with the basolateral nucleus of the amygdala (BLA) and the autonomic nervous system in the generation of anxiety disorders.[35]

All of the patients in the case reports experienced frequent panic attacks in addition to their other anxiety symptoms. Lactate sensitivity or an increased responsiveness to lactate might have caused some of their anxiety symptoms. Only one of the patients (Case #4) appeared to have hyperventilation as part of her clinical presentation. All of them had a therapeutic response to niacinamide, demonstrating its ability to reduce panic attacks.

L.C. Abbey has suggested that an insufficient supply of NAD would inhibit the conversion of lactate back to pyruvate, which would contribute to a high lactate-to-pyruvate ratio and, therefore, to anxiety.[36] In 3 out of 12 patients, Abbey found deficient levels of urinary N^1-methylnicotinamide normalized when optimal doses of B-complex vitamins were provided, to which she conjectured that an excess of NAD was required to drive the conversion of lactate to pyruvate. R.A. Buist also hypothesized that anxiety neurosis is associated with elevated blood lactate and an increased lactate-to-pyruvate ratio, to which effective treatment requires increasing niacin status (i.e., increasing NAD levels) through supplementation.[37]

The formation of lactate by the enzyme, lactate dehydrogenase, is the final product of anaerobic glycolysis in eukaryotic cells. Niacinamide

supplementation might result in an increased conversion of lactate to pyruvate, thus reversing the equilibrium of the pyruvate to lactate reaction (Figure 2). For example, when a patient with MELAS (mitochondrial encephalopathy, myopathy, lactic acidosis, and stroke-like episodes) syndrome was treated with 1000 mg of niacinamide four times daily, large reductions (50% or more) in blood lactate and pyruvate concentrations occurred by the third day of treatment.[38]

Optimal doses of niacinamide appear to be capable of reducing blood lactate and pyruvate concentrations. Patients with panic attacks likely have a greater demand placed upon anaerobic glycolysis due to the rapidity or shallowness of breathing that so often accompanies their anxiety attacks. Therefore, a greater amount of NAD obtained by means of niacinamide supplementation might help the tissues of the body, including the central nervous system, to oxidize lactate (obtained from the blood) to pyruvate readily, and, consequently, mitigate panic attacks, and hyperventilation (if present).

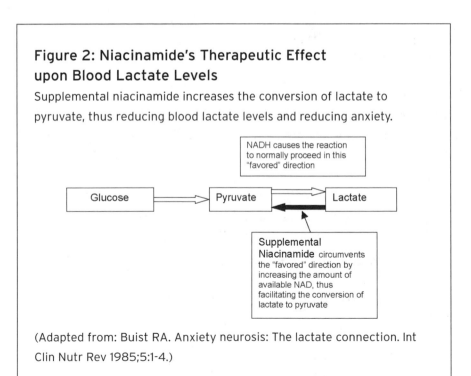

Figure 2: Niacinamide's Therapeutic Effect upon Blood Lactate Levels

Supplemental niacinamide increases the conversion of lactate to pyruvate, thus reducing blood lactate levels and reducing anxiety.

NADH causes the reaction to normally proceed in this "favored" direction

Glucose → Pyruvate ⇄ Lactate

Supplemental Niacinamide circumvents the "favored" direction by increasing the amount of available NAD, thus facilitating the conversion of lactate to pyruvate

(Adapted from: Buist RA. Anxiety neurosis: The lactate connection. Int Clin Nutr Rev 1985;5:1-4.)

Prescribing Vitamin B-3 (Niacinamide)

Most patients require a minimum of 2000 to 4500 mg per day to achieve therapeutic results. These dosages were derived from the work of A. Hoffer, who recommended 1500 to 6000 mg of niacinamide per day for all patients with psychiatric syndromes.[17] Patients usually experience relief of their symptoms within 1 month of taking the medication (personal observation). Doses between 1500 to 6000 mg per day have been safely used in children and adolescents for extended periods of time without any adverse side effects or complications such as clinical hepatitis.[39,40]

My four case-study patients tolerated optimal daily doses of niacinamide very well. Only one patient needed to reduce her dose from 3000 to 2000 mg per day due to feelings of not being present (perhaps derealization). The 28-year-old patient had problems swallowing the niacinamide tablets. For this reason, it might be necessary to switch some patients to capsules or powder forms of niacinamide.

Side Effects

The most common side effect with niacinamide is sedation,[41] but dry mouth and nausea have been the most common side effects that I have observed among some patients. There has been one case report linking very large daily doses of niacinamide (9 g per day) to hepatic toxicity.[42] The patient in the cited report had no evidence of clinical hepatitis when taking 2000 to 3000 mg per day of niacinamide, but did develop clinical hepatitis when the dose was increased to 9000 mg daily. All clinical abnormalities reverted to normal once the niacinamide was discontinued.

I never exceed prescribing 6000 mg per day of niacinamide since most patients will develop nausea and sometimes vomiting on this dose.[17] There is hardly any need to go above 4500 mg per day when treating anxiety. If nausea does occur, decreasing the dose by 1000 mg usually corrects the problem.

Therapeutic Recommendation

Optimal doses of niacinamide were effective in relieving the symptoms of anxiety in the four case-study patients. Even though niacinamide's mechanisms of action have not been substantiated from controlled clinical trials, this agent

appears to have a wide spectrum of beneficial effects upon anxiety disorders. Due to the relative absence of negative side effects and the availability of inexpensive niacinamide, this nutrient should be the first approach considered when patients are being prescribed medication for their anxiety disorders.

Evidence Grade

In keeping with the current trend in evidence-based medicine, an evidence grade has been assigned to the orthomolecular treatments reviewed in this book. These evidence-based summaries are not meant to provide an exhaustive account of all relevant sources. Rather, only those articles pertaining to anxiety or related psychiatric conditions involving orthomolecular treatments will be assigned evidence grades. These evidence grades are based on the hierarchy of evidence developed by the Oxford Centre for Evidence-Based Medicine (Table 11).[43]

Table 11: Grades of Evidence

A Systematic reviews of randomized controlled trials and/or randomized controlled trials with or without double-blind placebo control.

B Systematic reviews of observational studies and/or high-quality observational studies including cohort and case-control studies, and/or non-randomized controlled trials.

C Case-series, case-reports, and/or poor quality cohort and case-control studies.

D Expert opinion without explicit critical appraisal or based on physiology, bench research or "first principles."

Evidence-Based Summary of Articles Demonstrating the Therapeutic Effectiveness of Vitamin B-3 for the Treatment of Anxiety and/or Related Psychiatric Syndromes

Reference	Study Information	Grade
9	Three case reports describing the therapeutic effectiveness of niacinamide.	C

Reference	Study Information	Grade
10	One case report describing the therapeutic effectiveness of niacinamide.	C
12	A book describing the therapeutic effectiveness of optimal doses of niacinamide in 150 private patients seen over the course of 1 year (approximate time period from September 1941 to September 1942).	C
14,17	Expert opinion regarding the usefulness of vitamin B-3 as a treatment for various psychiatric conditions.	D
21	Psychiatric reference book pertaining to the therapeutic uses of vitamin B-3 (includes expert opinion, case reports and results of small controlled trials). The section on niacinamide and anxiety deals with expert opinions only.	D
22-27	Physiological and animal research pertaining to the benzodiazepine-like properties of niacinamide.	D

References

1. Prousky JE. Pellagra may be a rare secondary complication of anorexia nervosa: A systematic review of the literature. Altern Med Rev 2003;8:180-85.

2. Hawn LJ, Guldan GJ, Chillag SC, et al. A case of pellagra and a South Carolina history of the disorder. J S C Med Assoc 2003;99:220-23.

3. Prasad PVS, Babu A, Paul EK, et al. Myxoedema pellagra — a report of two cases. J Assoc Physicians India 2003;51:421-22.

4. Wallengren J, Thelin I. Pellagra-like skin lesions associated with Wernicke's encephalopathy in a heavy wine drinker. Acta Derm Venereol 2002;82:152-54.

5. Pitsavas S, Andreou C, Bascialla F, et al. Pellagra encephalopathy following B-complex vitamin treatment without niacin. Int J Psychiatry Med 2004;34:91-95.

6. Kertesz SG. Pellagra in 2 homeless men. Mayo Clin Proc 2001;76:315-18.

7. Lyon VB, Fairley JA. Anticonvulsant-induced pellagra. J Am Acad Dermatol 2002;46:597-99.

8. Kaur S, Goraya JS, Thami GP, et al. Pellagrous dermatitis induced by phenytoin. Pediatr Dermatol 2002;19:93.

9. Case reports #2 to #4, the analysis pertaining to niacinamide's benzodiazepine-like effects, and the prescribing information have been previously published in: Prousky JE. Orthomolecular treatment of anxiety disorders. Townsend Lett Doctors Patients 2005;259/260:82-87. Written permission was obtained from the publisher for the reproduced material contained in this chapter.

10. Case #1 taken from: Prousky JE. Niacinamide's potent role in alleviating anxiety with its benzodiazepine-like properties: A case report. J Orthomol Med 2004;19:104-110.

11. Hegyi J, Schwartz RA, Hegyi V. Pellagra: Dermatitis, dementia, and diarrhea. Int J Dermatol 2004;43:1-5.

12. Kaufman W. The Common Form of Niacin Amide Deficiency Disease: Aniacinamidosis. Bridgeport, CT: Yale University Press, 1943.

13. Green RG. Subclinical pellagra among penitentiary inmates. J Orthomolec Psych 1976;5:68-83.

14. Hoffer A. Vitamin B-3 dependency: Chronic pellagra. Townsend Lett Doctors Patients 2000;207:66-73.

15. Pauling L. Orthomolecular psychiatry. Varying the concentrations of substances normally present in the human body may control mental disease. Science 1968;160:265-71.

16. van Tiggelen CJM, Peperkamp JPC, Tertoolen JFW. Vitamin B12 levels of cerebrospinal fluid in patients with organic mental disorders. J Orthomolec Psych 1983;12:305-11.

17. Hoffer A. Vitamin B-3: Niacin and its amide. Townsend Lett Doctors Patients 1995;147:30-39.

18. Pauling L, Robinson AB, Oxley S, et al. Results of a loading test of ascorbic acid, niacinamide, and pyridoxine in schizophrenic subjects and controls. In Hawkins D, Pauling L (eds.). Orthomolecular Psychiatry. San Francisco, CA: W. H. Freeman and Company, 1973:18-34.

19. Cazzullo CL, Sacchetti E, Smeraldi E. N^1-methylnicotinamide excretion and affective disorders. Psychol Med 1976;6:265-70.

20. Ames BN, Elson-Schwab I, Silver EA. High-dose vitamin therapy stimulates variant enzymes with decreased coenzyme binding (increased K_m): Relevance to genetic diseases and polymorphisms. Am J Clin Nutr 2002;75:616-58.

21. Hoffer A. Nicotinic acid and niacinamide as sedatives. Niacin Therapy in Psychiatry. Springfield, IL: C.C. Thomas, 1962:24-31.

22. Möhler H, Polc C, Cumin R, et al. Nicotinamide is a brain constituent with benzodi-azepine-like actions. Nature 1979;278:563-65.

23. Slater P, Longman DA. Effects of diazepam and muscimol on GABA-mediated neu-rotransmission: Interactions with inosine and nicotinamide. Life Sci 1979;25:1963-67.

24. Kennedy B, Leonard BE. Similarity between the action of nicotinamide and diazepam on neurotransmitter metabolism in the rat. Biochem Soc Trans. 1980;8:59-60.

25. Lapin IP. Nicotinamide, inosine and hypoxanthine, putative endogenous ligands of the benzodiazepine receptor, opposite to diazepam are much more effective against kynurenine-induced seizures than against pentylenetetrazol-induced seizures. Pharmacol Biochem Behav 1981;14:589-93.

26. Markin RS, Murray WJ. Searching for the endogenous benzodiazepine using the graph theoretical approach. Pharm Res 1988;5:408-12.

27. Akhundov RA, Dzhafarova SA, Aliev AN. The search for new anticonvulsant agents based on nicotinamide. Eksp Klin Farmakol 1992;55:27-29.

28. Vescovi PP, Gerra G, Ippolito L, et al. Nicotinic acid effectiveness in the treatment of benzodiazepine withdrawal. Curr Ther Res 1987;41:1017-21.

29. Judd LE, Poskitt BL. Pellagra in a patient with an eating disorder. Br J Dermatol 1991;125:71-72.

30. Gedye A. Hypothesized treatment for migraine using low doses of tryptophan, niacin, calcium, caffeine, and acetylsalicylic acid. Med Hypotheses 2001;56:91-94.

31. Shibata Y, Nishimoto Y, Takeuchi F, et al. Tryptophan metabolism in various nutri-tive conditions. Acta vitamin enzymol 1973;29:190-93.

32. Den Boer JA, Westenberg HG, Klompmakers AA, et al. Behavioral biochemical and neuroendocrine concomitants of lactate-induced panic anxiety. Biol Psychiatry 1989;26:612-22.

33. Leibowitz MR, Gorman JM, Fyer A, et al. Possible mechanisms for lactate's induction of panic. Am J Psychiatry 1986;143:495-502.

34. Leibowitz MR, Gorman JM, Fyer AJ, et al. Lactate provocation of panic attacks. II. Biochemical and physiological findings. Arch Gen Psychiatry 1985;42:709-19.

35. Shekhar A, Sajdyk TJ, Gehlert DR, et al. The amygdala, panic disorder, and cardio-vascular reponses. Ann N Y Acad Sci 2003;985:308-25.

36. Abbey LC. Agoraphobia. Part 1 – agoraphobia: A nutritionally responsive disorder. J Orthomolec Psych 1982;11:243-53.

37. Buist RA. Anxiety neurosis: The lactate connection. Int Clin Nutr Rev 1985;5:1-4.

38. Majamaa K, Rusanen H, Remes AM, et al. Increase of blood NAD+ and attenuation of lactacidemia during nicotinamide treatment of a patient with MELAS syndrome. Life Sci 1996;58:691-99.

39. Hoffer A. Vitamin B_3 dependent child. Schizophrenia 1971;3:107-13.

40. Hoffer A. Dr. Hoffer's ABC of Natural Nutrition for Children. Kingston, ON: Quarry Press Inc, 1999; rev. ed. Healing Children's Attention and Behavior Disorders. Toronto, ON: CCNM Press Inc., 2004.

41. Werbach MR. Adverse effects of nutritional supplements. Foundations of Nutritional Medicine. Tarzanna, CA: Third Line Press, Inc, 1997:133-60.

42. Winter SL, Boyer JL. Hepatic toxicity from large doses of vitamin B_3 (nicotinamide). N Engl J Med 1973;289:1180-82.

43. Centre for Evidence-Based Medicine [www.cebm.net/levels_of_evidence.asp#levels]

TREATING ANXIETY WITH VITAMIN B-12 (COBALAMIN)

⑦

Vitamin B-12 (cobalamin) is involved in numerous biochemical reactions as a cofactor and coenzyme. Its main functions involve DNA synthesis, methionine synthesis from homocysteine, and conversion of propionyl into succinyl coenzyme A from methylmalonate.[1] The psychiatric manifestations of vitamin B-12 deficiency include agitation or restlessness, dementia, depression, fatigue, irritability, panic and phobic disorders, personality change, psychosis, mild memory impairment, and negativism.[2,3] Patients most likely to develop vitamin B-12 deficiency have clinical conditions, such as atrophic gastritis, bacterial overgrowth of the small intestine, or pernicious anemia.

Vitamin B-12 and Anxiety Studies

Vitamin B-12 clearly helps those who are deficient in this nutrient, but there are many anxiety patients who seem to benefit psychologically from regular vitamin B-12 injections despite the absence of diseases

and serologic evidence of vitamin B-12 deficiency.

In a study involving two subjects, each was randomized to receive weekly injections of hydroxocobalamin or placebo (phenolsulfonphthalein) for 25 weeks.[4] Prior to the study and after the study, gastric analysis was performed, and they were found to have no absorption problems. Each week during the study, the subjects were given a questionnaire ranking various items, such as the helpfulness of the injection and the duration of benefit. They were also asked if the injection improved energy, pep, strength, depression, nerves, appetite, tremor, fatigue, and outlook. Even though there were no differences found between the hydroxocobalamin and placebo, the subjects did report a benefit from the hydroxocobalamin in terms of reduced nervousness and fatigue.

In another study, a double-blind cross-over trial involving 28 subjects complaining of tiredness, injections of hydroxocobalamin or matching placebo were administered.[5] The subjects were given 5 mg of hydroxocobalamin twice weekly for 2 weeks, followed by a rest period of two weeks, and then a similar course of matching placebo injections. Symptoms were assessed by a daily self-rating method that included appetite, mood, energy, sleep, and general feeling of well-being. Those subjects who received the placebo in the first 2-week period showed a favorable response to hydroxocobalamin in the second period in all measurements. Specifically, statistical significance ($p=0.006$) was achieved with respect to general well-being, while "happiness" also showed statistical significance ($p=0.032$).

The data presented indicates a potential anxiolytic benefit from regular intramuscular (IM) injections of vitamin B-12. The case described below is an example of the clinical response possible with vitamin B-12.

Case Report: Anxiety Attacks

A 25-year-old presented to my private practice on August 7, 2004, with chief complaints of anxiety and depression. [6] The onset of the patient's anxiety began 2 years previously when she started her new job as a graphic designer. She described symptoms of heart racing, sweating, dizziness, stomach pain, nausea, vomiting, light-headedness, and diarrhea. She reported difficulties falling asleep and would even wake up with her heart

beating very fast. She was currently on 25 mg of paroxetine daily, and had taken it for the past 2 years.

The anxiety attacks mainly occurred at work, which often forced her to leave early. She also described a history of depression that began when she was 12 years old. The depression improved initially when she first started the paroxetine, but now it seemed to have worsened.

Physical examination revealed a slightly overweight female, with normal vital signs and normal findings of all other systems.

She was diagnosed with GAD and prescribed a program of 120 mg/day of *Ginkgo biloba* extract to help with her sexual dysfunction, 1 teaspoon of fish oil, and niacinamide at increasing doses until 1000 mg three times daily was reached.

At a follow-up appointment on September 9, 2004, the patient complained of feeling sick and nauseous with the niacinamide. She also reported feeling paranoid and panicky. The patient had experienced anxiety for the previous 2 weeks and was crying all the time. She was told to reduce the niacinamide to 500 mg three times daily, to add 50 mg of 5-HTP three times daily, and was given 1000 micrograms (mcg) of hydroxocobalamin by IM injection. For the next 5 weeks, the patient received injections of hydroxocobalamin twice weekly and discontinued all the other prescribed supplements on her own.

On October 16, 2004, the patient described herself as being free of any anxiety and panic. She had not had a panic attack since September 9. About 1 month later, on November 13, 2004, the patient returned for another vitamin B-12 injection. She described a slight worsening of her anxiety and panic since stopping the twice-weekly injections. For the previous 2 weeks, the patient had experienced spells of nausea and hot flushes; however, she had not needed to leave work early as she did in the past. Another 1000 mcg of hydroxocobalamin was administered IM, and she was instructed to return more regularly for the injections.

In a follow-up email on November 17, the patient reported the following: "I've been panic free since the weekend, which is nice. I haven't had hot flashes or heart beating fast in the morning either. I'm starting to think it [the B-12 shots] has a lot to do with how well I have been feeling!"

Mechanism of Action

A study involving 30 patients with OCD, 30 schizophrenic patients, and 30 healthy controls assessed serum levels of vitamin B-12 and folic acid.[7] Although folic acid levels did not differ between the patient and control groups, the levels of vitamin B-12 showed marked group differences. In 6 of the 30 patients (20%) with OCD, the serum levels of vitamin B-12 were less than 200 pg/ml. The control and schizophrenic groups had only one patient each (3.33%) with a low vitamin B-12 level.

In another study evaluating the vitamin status of more than 1000 healthy men, those who were borderline deficient in vitamin B-12 were substantially more anxious at the time of the study.[8] None of the men with the borderline vitamin B-12 deficiency were ordinarily anxious individuals. It is interesting to note that vitamin B-12 is involved in the synthesis of serotonin, and that serotonin dysfunction is associated with OCD and other types of anxiety. It seems possible that supplemental or injectable vitamin B-12 would benefit anxiety patients by increasing the production of serotonin.

Another conceivable benefit from optimizing the serum levels of vitamin B-12 would be the resulting increase in the amount of vitamin B-12 that would gain entrance into the central nervous system (CNS). In a study involving 13 patients (29 to 50 years of age) with neurasthenic symptoms, the vitamin B-12 levels were assessed in both the serum and cerebrospinal fluid (CSF).[9,10] All 13 patients had normal serum levels of vitamin B-12 (range, 280 to 750 pg/ml), but 11 of them had deficient CSF levels (<5 pg/ml). The other two patients had CSF levels of 10 pg/ml and 15 pg/ml, respectively. By not performing routine CSF analysis, the majority of these patients would not have been found to have a vitamin B-12 deficiency. The authors concluded their report by stating that all patients displaying organic mental symptoms should have their CSF levels of vitamin B-12 assessed.

In a similar study involving 49 patients with organic mental disorders, deficient CSF levels of vitamin B-12 (<5 pg/ml) were found in 30 patients.[11] When the serum levels of vitamin B-12 were tested, normal values (200 to 800 pg/ml) were found in 45 of them, indicating a marked difference between both compartments. A group of 10 patients were also given

injectable hydroxocobalamin at a dose of 1000 mcg twice weekly for 6 weeks. The injectable group was also instructed to take a capsule containing 50 mg zinc DL-aspartate and 250 mg of taurine three times daily. This group was compared against a group of two patients given 0.1 mg of oral cyanocobalamin in a capsule with 50 mg zinc DL-aspartate and 250 mg taurine, prescribed three times daily for 6 weeks. The group given the injections achieved a much greater increase in their CSF levels of vitamin B-12, as can be seen from Table 12. The best way to achieve high CSF levels of vitamin B-12 is probably by the administration of regular IM injections.

Given that serum levels of vitamin B-12 can be normal yet deficient in the CSF, patients responding to regular IM injections of hydroxocobalamin might have an improvement in their anxiety due to marked (supraphysiological) increases in their CSF vitamin B-12 levels, or from the correction of deficient CSF levels of vitamin B-12.

The major transport protein that shuttles vitamin B-12 into the CNS is transcobalamin II. High serum levels of vitamin B12 might also increase CSF levels by circumventing defects in carrier-mediated facilitated diffusion by optimizing the functioning of transcobalamin II and enabling more of vitamin B-12 to shuttle into the brain.[12]

These reasons support the idea that many patients with anxiety have an increased need for or dependency on vitamin B-12, which cannot be satisfied through diet alone.

Table 12: CSF and Serum Differences between Injectable and Oral Vitamin B-12

Group	Pre-Treatment Serum B-12 (pg/ml)	Pre-Treatment CSF B-12 (pg/ml)	Post-Treatment Serum B-12 (pg/ml)	Post-Treatment CSF B-12 (pg/ml)
Injectable (10 Patients)	310	<5	>2400	70
Oral (Patient #1)	430	14	2400	21
Oral (Patient #2)	450	<5	>2400	9.6

Prescribing Vitamin B-12

When trying to control symptoms of anxiety, it is necessary for patients to receive regular IM injections or take the vitamin orally in optimal daily doses. The frequency and amount of vitamin B-12 is dependent upon the serum level desired.

According to J. Dommisse, the psychological benefits of vitamin B-12 are best achieved when serum levels range from 1000 to 2000 pg/ml.[13] However, this serum range might not be optimal; H.L. Newbold demonstrated that extremely high serum levels (average 465,173 pg/ml) have relatively no side effects and appears to be necessary when improving patients' psychological health.[14] To get serum levels in the range purported by Dommisse, the amount of vitamin B-12 is at least 1000 mcg given IM every 2 weeks, or at least 5 mg (5000 mcg) of B12 taken orally each day. To bring serum levels in the range of Newbold, the amount of vitamin B-12 required is 3000 mcg given IM four times each week, or 9000 mcg IM daily.

The preferred form of oral vitamin B-12 is methylcobalamin because it has greater tissue retention than cyanocobalamin and appears to produce good clinical results irrespective of the method of administration.[15]

In my clinical experience, patients getting the best therapeutic response from vitamin B-12 are those presenting with anxiety and some level of fatigue and/or depression. Such patients typically require 1000 to 5000 mcg of IM vitamin B-12 once or twice each week until their anxiety symptoms improve. The serum level of vitamin B-12 usually needs to be greater than or equal to 1000 pg/ml to have any anxiolytic benefits. The best form of injectable vitamin B-12 is hydroxocobalamin, as can be seen from Table 13.[16]

Table 13: Effectiveness and Route of Administration for Vitamin B-12

Route	Maximum increase from baseline	24-hour urinary excretion
Oral	43%	0.009%
Sublingual	34%	0.004%
Parenteral (hydroxocobalamin)	106%	2.7%
Parenteral (cyanocobalamin)	78%	4.2%

Side Effect

The only rare side effect from supplemental vitamin B-12 is an acneiform exanthema, particularly in women.[17] These lesions have only been reported to occur from oral supplementation, but I have seen the same acneiform eruption occur (albeit, rarely) from hydroxocobalamin injections. The lesions consist of loosely disseminated small papules or papulopustules on the face, the upper parts of the back, and chest, and these can spread to the upper arm. They go away within a week once the injections have been discontinued.

Therapeutic Recommendation

Vitamin B-12 is an excellent anxiolytic agent. It is safe, inexpensive, and relatively pain-free when given by injection. All patients presenting with a combination of anxiety, depression, and/or fatigue should have their serum levels measured before treatment is instituted. Once vitamin B-12 is administered regularly, serum levels should be increased to an amount greater than or equal to 1000 pg/ml in order for patients to experience significant relief of their anxiety symptoms.

Evidence-Based Summary of Articles Demonstrating the Therapeutic Effectiveness of Oral and/or Injectable Vitamin B-12 for the Treatment of Anxiety and/or Related Psychiatric Syndromes

Reference	Study Information	Grade
3	Expert opinion about the therapeutic effectiveness of vitamin B-12.	D
4	Double-blind study of 2 subjects given placebo or injectable vitamin B-12.	B
5	Double-blind crossover trial involving 28 subjects given injectable vitamin B-12 and placebo.	B
6	Case report demonstrating a favorable response to injectable vitamin B-12.	C
13	Case report and expert opinion.	C
14	Case series demonstrating favorable therapeutic responses from injectable vitamin B-12.	C

References

1. Andrès E, Loukili NH, Noel E, et al. Vitamin B_{12} (cobalamin) deficiency in elderly patients. CMAJ 2004;171:251-59.

2. OH RC, Brown DL. Vitamin B_{12} deficiency. Am Fam Physician 2003;67:979-86, 993-94.

3. Dommisse J. Subtle vitamin B-12 deficiency and psychiatry: A largely unnoticed but devastating relationship? Med Hypotheses 1991;34:131-40.

4. Schilling RF. Is vitamin B12 a tonic? Wis Med J 1971;70:143-44.

5. Ellis FR, Nasser S. A pilot study of vitamin B_{12} in the treatment of tiredness. Br J Nutr 1973;30:277-83.

6. Prousky JE. Orthomolecular treatment of anxiety disorders. Townsend Lett Doctors Patients 2005;259/260:82-87.

7. Hermesh H, Weizman A, Shahar A, et al. Vitamin B_{12} and folic acid serum levels in obsessive compulsive disorder. Acta Psychiatr Scand 1988;78:8-10.

8. Heseker H, Kubler W, Pudel V, et al. Psychological disorders as early symptoms of a mild-to-moderate vitamin deficiency. Ann NY Acad Sci 1992;669:352-57.

9. van Tiggelen CJM, Peperkamp JPC, Tertoolen JFW. Assessment of vitamin B_{12} status in CSF. Am J Psychiatry 1984;141:136-37.

10. Neurasthenia is an old term denoting unexplained chronic fatigue and lassitude with accompanying symptoms such as nervousness, irritability, anxiety, depression, headache, and insomnia. Most neurasthenic patients have some type of anxiety neurosis or chronic state of psychological tension.

11. van Tiggelen CJM, Peperkamp JPC, Tertoolen JFW. Vitamin B12 levels of cerebrospinal fluid in patients with organic mental disorders. J Orthomolec Psych 1983;12:305-11.

12. Regland B, Abrahamsson L, Blennow K, et al. Vitamin B_{12} in CSF: reduced CSF/serum B_{12} ratio in demented men. Acta Neurol Scand 1992;85:276-81.

13. Dommisse J. Case report: The psychiatric manifestations of B12 deficiency. Prim Psychiatry 1996;3,4:50-55.

14. Newbold HL. Vitamin B-12: Placebo or neglected therapeutic tool? Med Hypotheses 1989;28:155-164.

15. Methylcobalamin. Altern Med Rev 1998;3:461-63.

16. Sohler A, Pfeiffer CC, Kowalski T. Effectiveness and route of administration of vitamin B12. Int Clin Nut Rev 1989;9:64-65.

17. Werbach MR, Moss J. Acne vulgaris. Textbook of Nutritional Medicine. Tarzana, CA: Third Line Press, Inc., 1999:67-70.

TREATING ANXIETY WITH B-VITAMINS, INOSITOL, AND ESSENTIAL FATTY ACIDS

⑦

The other members of the vitamin B family include thiamine (vitamin B-1), riboflavin (vitamin B-2), pantothenic acid (vitamin B-5), pyridoxine (vitamin B-6), and folic acid. Only the B-vitamins with known anxiolytic effects will be discussed here. Inositol will be included in this discussion since it possesses biochemical properties similar to some of the B-vitamins and has documented anxiolytic effects. There will also be a brief discussion of omega-3 essential fatty acids (EFAs) because these types of lipids may have a favorable effect upon anxiety.

Vitamin B-1 (Thiamine)

Numerous studies demonstrate that lactate sensitivity or an increased responsiveness to lactate can provoke anxiety symptoms. In terms of anxiety treatment, thiamine might be helpful because it can reduce the production of lactate.

In a study by R.A. Buist, thiamine's anxiolytic properties were reported to result from its coenzyme function in the pyruvate dehydrogenase enzyme. The net effect of this would be a reduction in blood lactate and less anxiety symptoms due to an increased conversion of pyruvate to acetyl-CoA.[1]

A published case report has also demonstrated the ability of supplemental thiamine to reduce lactate levels.[2] The case described a patient with a deficiency of pyruvate dehydrogenase and a combination of congenital biochemical and clinical abnormalities: lactic acidosis, muscular hypotonia, and severe ataxia. The pyruvate dehydrogenase deficiency and the accompanying abnormalities were reversed by the daily administration of optimal doses (1.8 g) of thiamine.[2]

Chronic borderline thiamine deficiency may also be associated with a heightened experience of anxiety,[3] possibly the result of an increased production of lactate. Although no controlled trials have assessed the therapeutic ability of thiamine to reduce anxiety, it appears to have some therapeutic value in managing anxiety.

Vitamin B-6 (Pyridoxine)

Pyridoxine has three specific biochemical functions that probably help people who suffer from anxiety. The first function has to do with its role in converting tryptophan to serotonin. In a small experimental study of 13 patients with hyperventilation syndrome, all subjects were supplemented with L-tryptophan and pyridoxine.[4] Nine patients (70%) were free of their hyperventilation attacks after 3 weeks of treatment. Repeat testing demonstrated that the abnormal xanthurenic acid excretion normalized in all patients. Even though supplementation was discontinued after 4 weeks, the 9 patients who had a favorable response continued symptom-free during 3 months of follow-up. The authors of this study theorized that a marginal deficiency of pyridoxine had triggered the hyperventilation syndrome by causing serotonin depletion.

The second function involves pyridoxine's role as a coenzyme for glutamic acid decarboxylase. This coenzyme facilitates the conversion of glutamic acid to GABA (an inhibitory neurotransmitter). GABA plays a role in modulation of anxiety. Some patients with anxiety may have a decreased

binding affinity of the pyridoxine coenzyme to glutamic acid decarboxylase. This would lead to an underproduction of GABA and more anxiety would result. In such patients, optimal amounts of pyridoxine would ensure the proper functioning of this enzyme.

Pyridoxine's third function involves its redirection of the pyruvate to lactate reaction. By augmenting transamination reactions, pyridoxine increases substrate availability to the Krebs cycle. That facilitates oxidative metabolism, and reduces the amount of lactate produced.[1]

By virtue of its mechanisms of action, pyridoxine is helpful in the treatment of anxiety. Even though a pyridoxine deficiency has been shown to increase the tendency to become anxious,[3] I believe its main benefits involve correcting a vitamin B-6 dependency disorder.

B Vitamins

Not all the B vitamins have known anxiolytic properties, but when they are used in combination, the B vitamins can produce favorable clinical results.

In a study by L.C. Abbey, B-vitamin-dependent enzymopathies were assessed in 12 patients with agoraphobia.[5] All 12 patients were subjected to the same laboratory tests to determine the presence or absence of vitamin-dependent enzymopathies. Ten of 12 patients had more than one enzymopathy; 2 patients had more than two enzymopathies and 1 patient had more than three enzymopathies. An abnormality in thiamine was found in 7 of the 12 patients, which was the most common of the tested enzymopathies. Pyridoxine was second, and occurred in 6 of the 12 patients.

All of Abbey's patients required 200 to 500 mg of the B vitamins to resolve both the associated enzymatic defects and the symptoms of their anxiety and panic. Dramatic improvements occurred in 83% of the patients.

Inositol

Inositol is an important intracellular second-messenger precursor that is used by some muscarinic, noradrenergic alpha[1], and serotonergic (5-HT$_2$)

receptors. When supplemented at optimal doses peripherally, inositol gains entrance into the brain and significantly raises brain levels.[6]

In an early report by C.C. Pfeiffer, the effect of inositol was assessed using quantitative brain waves on patients and normal subjects.[7] Inositol was shown to have an anti-anxiety effect comparable to librium and meprobamate. It was also reported that patients taking inositol could often discontinue their daily dose of valium and meprobamate.

In a double-blind, placebo-controlled, crossover trial, 21 patients with panic disorder (with or without agoraphobia) were given 12 g of inositol each day for 4 weeks.[8] During a 1 week "run-in" phase, patients received either a placebo or no medication. After this period, patients were randomly allocated to placebo or inositol for 4 weeks. Then they were switched to the alternate treatment for another 4 weeks. Patients recorded daily panic diaries during the study period. Inositol was significantly more effective than placebo in reducing the severity and frequency of panic attacks, and in reducing the severity of agoraphobia. Inositol use was not associated with any substantial side effects. The authors concluded that inositol is a novel pharmacological agent producing clinically meaningful results. They also stated that future research should be directed at replicating this study, or using higher doses of inositol possibly to increase its therapeutic effect.

In a similar trial, inositol was given to 13 patients with OCD.[9] This trial used the same methods as described in the panic disorder study, except that the dosage of inositol was 18 g per day for a duration of 6 weeks. The patients had a significant therapeutic response when taking inositol compared to placebo per their lower scores on the Yale-Brown Obsessive Compulsive Scale. The authors of this study concluded that inositol is effective in the management of depression, panic, and OCD, disorders that respond favorably to SSRIs.

Essential Fatty Acids

D.O. Rudin has proposed that an omega-3 essential fatty acid deficiency may lead to "substrate pellagra" even when the diet contains adequate amounts of tryptophan and B-vitamins.[10] Bearing in mind that the modern diet hardly contains 20% of omega-3 EFAs, substrate pellagra

may develop in susceptible individuals.

Substrate pellagra is characterized by alterations in thought (schizophrenia), mood (manic-depressive psychosis), and neurotic fears (agoraphobia). Other symptoms are irritable bowel syndrome, dermatitis, tinnitus, and fatigue. In Rudin's report, 3 of 4 patients with a history of agoraphobia for 10 or more years improved after supplementing with flaxseed (linseed) oil for 2 to 3 months. The dose of flaxseed oil ranged from 2 to 6 tablespoons daily and contained 50% alpha-linolenic acid.

Minerals, antioxidants, and B vitamins (especially pyridoxine), in conjunction with optimal amounts of omega-3 EFAs, produce necessary prostaglandins of the three series. Rudin considered the production of these prostaglandins to be absolutely required in order to improve or reverse the clinical presentation of substrate pellagra.

Prescribing B Vitamins and Essential Fatty Acids

Thiamine

When optimal doses of thiamine are used, side effects are rare, but can include nervousness, itching, flushing, shortness of breath, tachycardia, a sensation of heat, perfuse perspiration, headache, insomnia, irritability, muscle tremors, and weakness.[11] I have treated several patients for cardiovascular disease with very high doses of thiamine (2 g or more per day), and have not seen any of these reported side effects.

Pyridoxine

Pyridoxine has several unusual side effects that must be considered when prescribing optimal doses.[11] An acneiform exanthema, particularly in women, can occur during treatment with this vitamin. The lesions consist of loosely disseminated small papules or papulopustules on the face, the upper parts of the back and chest, and can spread to the upper arm. They go away within a short period of time once the vitamin is discontinued. Another side effect is sensory neuropathy, which can occur when doses as low as 200 mg are taken daily over 3 years, but usually the doses need to be in the range of 2 to 5 g daily to produce this side effect. The last of the worrisome side effects include central nervous system toxicity. To produce this in humans, doses at least 100 times

the recommended daily allowance of pyridoxine (1.6 to 2.0 mg daily) would have to be administered.

In terms of the safety of pyridoxine, B. Rimland has seen only four cases of sensory neuropathy in almost 30 years of clinical experience with the vitamin.[12] Concerns about vitamin B-6, according to this expert, are grossly overstated.

To reduce any potential side effects from pyridoxine treatment, it is best taken with optimal doses of magnesium (about 3 to 4 mg per pound of body weight or 6.6 to 8.8 mg per kg of body weight) and with other B-vitamins.[12,13]

B-Complex

A B-complex 100 can also be prescribed two to five times daily with meals, depending on the therapeutic response. Side effects are minimal, but can include nausea if taken on an empty stomach and an increased yellowing of the urine (a harmless side effect).

Inositol

The optimal dose of inositol is 12 to 18 g daily taken in divided doses with fruit juice. Patients can have significant gastrointestinal bloating and indigestion with these large doses (personal observation). I recommend that the dose be increased gradually over several weeks until 12 to 18 g are reached.

Omega-3 EFAs

Flaxseed Oil

Omega-3 EFAs are available in flaxseed oil. The dose of flaxseed oil should be similar to what D.O. Rudin had his patients take (2 to 6 tablespoons daily). Supplementation with flaxseed oil can cause side effects in a very small percentage of individuals (about 3%), such as hypomania, mania, or other behavioral changes.[10,14] Other common side effects from flaxseed oil include loose stools or diarrhea (personal observation).

Fish Oils

Despite the clinical utility of flaxseed oil, it is not biologically equivalent to other types of omega-3 fatty acids, such as those found in fish.[15] Fish oils are preferable because they contain biologically more potent sources of

omega-3 fatty acids, which include eicosapentaenoic acid (EPA) and docosahexaenoic acid (DHA). These types of omega-3 EFAs have a wide spectrum of neurobehavioral effects,[16] and might be more efficacious than flaxseed oil for the treatment of anxiety. However, one recent clinical trial assessing the efficacy of adjunctive EPA (2 g daily in addition to standard SSRI treatment) found no therapeutic benefits in 11 patients with OCD.[17]

At present, it is unclear if fish oil sources of EFAs have any therapeutic value for the treatment of anxiety. Daily doses should provide a minimum of 1 g of EPA daily to have a successful outcome,[16] but better results might be more achievable with higher daily doses of a supplement containing both EPA and DHA.

The most common side effects from fish oil supplements are gastrointestinal, consisting of mild dyspepsia, belching, increased flatulence, diarrhea, or a fishy aftertaste. Side effects can be minimized if taken with food or by taking an enteric-coated fish oil preparation.[11]

Therapeutic Recommendation

All of these orthomolecular treatments may be extremely effective for the management of anxiety. Although none of them has been subjected to large controlled trials, this should not prevent their use as first-line treatments. The common side effects are minimal and serious side effects are extremely rare. These nutrients appear to have substantial therapeutic effects based on their known and theoretical mechanisms of action.

Evidence-Based Summary of Articles Demonstrating the Therapeutic Effectiveness of B-vitamins, Inositol, and Omega-3 Essential Fatty Acids for the Treatment of Anxiety and/or Related Psychiatric Syndromes

Reference	Study Information	Grade
1	Expert opinion and experimental data pertaining to the value of various B-vitamins (especially, thiamin, pyridoxine, and niacin/niacinamide) and magnesium for the treatment of anxiety neurosis.	D

Reference	Study Information	Grade
4	Small experimental study on patients with hyperventilation syndrome who were given supplemental vitamin B-6 and L-tryptophan.	C
5	Small experimental trial of 12 patients taking B-complex vitamins to correct various enzymopathies.	C
7	Expert opinion and some experimental data demonstrating that inositol has an anti-anxiety effect comparable to librium and meprobamate.	D
8	A double-blind, placebo-controlled, crossover trial, involving 21 patients with panic disorder (with or without agoraphobia) who were given 12 g of inositol each day for 4 weeks.	A
9	In a similar trial, inositol was given to 13 patients with OCD. This trial used the same methods as described in the other inositol study, except that the dosage of inositol was 18 g per day for a duration of 6 weeks.	A
10	75% of patients with a history of agoraphobia for 10 or more years improved after supplementing with flaxseed (linseed) oil for 2 to 3 months.	C

References

1. Buist RA. Anxiety neurosis: The lactate connection. Int Clin Nutr Rev 1985;5:1-4.

2. Wick H, Schweizer K, Baumgartner R. Thiamine dependency in a patient with congenital lacticacidaemia. Agents Actions 1977;7:405-10.

3. Heseker H, Kubler W, Pudel V, et al. Psychological disorders as early symptoms of a mild-to-moderate vitamin deficiency. Ann NY Acad Sci 1992;669:352-57.

4. Hoes MJ, Colla P, Folgering N. Hyperventilation syndrome, treatment with L-tryptophan and pyridoxine; Predictive value of xanthurenic acid excretion. J Orthomolec Psych 1981;10:7-15.

5. Abbey LC. Agoraphobia. Part 1 – agoraphobia: A nutritionally responsive disorder. J Orthomolec Psych 1982;11:243-53.

6. Benjamin J, Agam G, Levine J, et al. Inositol treatment in psychiatry. Psychopharmacol Bull 1995;31:167-75.

7. Pfeiffer CC. Mental and Elemental Nutrients. New Canaan, CT: Keats Publishing, Inc., 1975:145.

8. Benjamin J, Levine J, Fux M, et al. Double-blind, placebo-controlled, crossover trial of inositol treatment for panic disorder. Am J Psychiatry 1995;152:1084-86.

9. Fux M, Levine J, Aviv A, et al. Inositol treatment of obsessive-compulsive disorder. Am J Psychiatry 1996;153:1219-21.

10. Rudin DO. The major psychoses and neuroses as omega-3 essential fatty acid deficiency syndrome: substrate pellagra. Biol Psychiatry 1981;16:837-50.

11. Werbach MR. Adverse effects of nutritional supplements. Foundations of Nutritional Medicine. Tarzana, CA: Third Line Press, Inc., 1997:133-60.

12. Rimland B. Vitamin B6 and autism: The safety issue. Autism Res Rev Int 1996;10(3):3.

13. Rimland B. What is the right 'dosage' for vitamin B6, DMG, and other nutrients useful in autism? Autism Res Rev Int 1997;11(4):3.

14. Kinrys G. Hypomania associated with omega3 fatty acids. Arch Gen Psychiatry 2000;57:715-16.

15. Ipatova OM, Prozorovskaia NM, Baranova VS, et al. Biological activity of linseed oil as the source of omega-3 alpha-linolenic acid. Biomed Khim 2004;50:25-43.

16. Logan A. Neurobehavioral aspects of omega-3 fatty acids: possible mechanisms and therapeutic value in major depression. Altern Med Rev 2003;8:410-25.

17. Fux M, Benjamin J, Nemets B. A placebo-controlled cross-over trial of adjunctive EPA in OCD. J Psychiatr Res 2004;38:323-25.

TREATING ANXIETY WITH MINERALS

Three minerals appear to have clinical utility for the treatment of anxiety: calcium, magnesium, and selenium. They can be useful as adjunctive or supportive treatments, but are probably not as efficacious when used as first-line treatments.

When evaluating patients with symptoms of anxiety, the clinician might consider specific laboratory testing for calcium and magnesium if the initial presentation includes muscle tension, tetany, and other neuropsychiatric manifestations.

Calcium

A few case reports have been published that demonstrated an association between hypocalcemia and organic anxiety syndrome, and the correction of the syndrome once the blood calcium level was restored to normal.[1]

The first case involved a 49-year-old postmenopausal vegetarian female with a 30-year history of generalized anxiety. She had symptoms

of an inability to relax, trembling, sweating, apprehensiveness, worry, insomnia, and occasional depression, with an exacerbation of these symptoms with stress. Upon evaluation, it was discovered that she had marked osteoporosis and a serum calcium level of 7.2 mg/dL (reference range: 8.5 to 10.5 mg/dL). Her anxiety was improved by the prescription of estrogens and the restoration of her calcium level to normal.

The second case was of a 58-year-old insulin-dependent diabetic female with a 35-year history of generalized anxiety, and symptoms of worry, fear, sweating, shaking, insomnia, and mild depression. On one particular day, all of her symptoms worsened, and she experienced more frequent panic attacks. She also developed muscle spasms, stuttering, and tetany. A positive Chvostek's sign confirmed the tetany. Laboratory testing revealed a serum calcium level that was below normal at 6.1 mg/dL. She was eventually diagnosed with idiopathic hypoparathyroidism. Once she received proper treatment, her anxiety was reduced to its former level.

In a third case report, calcium supplementation corrected the hypocalcemia and associated anxiety in a patient with severe neuropsychiatric manifestations following ablation of a parathyroid adenoma.[2] In other reports cited by M.R. Werbach, a high calcium diet significantly helped two patients with severe anxiety symptoms, but would probably not help patients with a confirmed deficiency of calcium (due to hypoparathyroidism) in their blood.[3]

Magnesium

R. A. Buist has indicated that magnesium depletion is associated with an increased lactate-to-pyruvate ratio. Magnesium supplementation should help by improving magnesium status, reducing the lactate-to-pyruvate ratio, and activating glycolytic enzymes.[4]

In a similar report, patients displaying weakness, latent tetany, anxiety, and psychosomatic disorders should have their serum magnesium levels checked because chronic magnesium deficit may contribute to this syndrome.[5]

Combination Mineral Supplement

A combination supplement containing calcium, magnesium, and potassium has been promoted as an effective alternative to benzodiazepine medications.[6] Each pill contains 145 mg of magnesium, 58 mg of calcium, and 146 mg of potassium complexed with the salt of phosphoric acid mono-(2-aminoethylester). Apparently, the ethanol amino phosphoric acid allows these minerals to gain better access to human neuronal cell membranes and myelin sheaths, and has a regulating effect upon the electrophysiological processes of the nervous system. Since there are no formal clinical trials or published reports examining the efficacy of this combination supplement upon anxiety, it is difficult to ascertain if it has any benefits.

Selenium

In a double-blind crossover study, 50 subjects received 100 mcg of selenium or placebo for 5 weeks.[7] Subjects were given the Profile of Mood States to fill out during the study. They were also given a food frequency questionnaire that estimated their dietary intake of selenium. An adequate intake of selenium was correlated with a general elevation of mood and less anxiety. Those subjects with the lowest estimated level of selenium in their diets had a greater amount of reported improvements in symptoms of anxiety, depression, and tiredness following 5 weeks of supplementation.

Prescribing Minerals

Calcium

The dose of oral calcium that might benefit patients with documented hypocalcemia is 1000 mg daily.[8] Even anxiety patients who do not have a "true" calcium deficiency might benefit from this dose as well, but the clinician ought to try increasing dietary sources of calcium before initiating calcium supplementation. There are no significant side effects to worry about with this daily dose of calcium.

Magnesium

For magnesium, the repletion dose is around 5 mg per kg of body weight each day. The best proof that the anxiety patient has a magnesium-responsive condition is to prescribe the repletion dose and assess whether or not the troublesome symptoms (e.g., some combination of latent tetany, hyperventilation syndrome, spasmophilia, chronic fatigue syndrome, and neurocirculatory asthenia) have ameliorated.[9] Side effects with magnesium are rare, but can include gastrointestinal disturbances (e.g., diarrhea), dizziness, or faintness due to hypotension, as well as sluggishness, cognitive impairment, and depression if excessive doses are administered.[10]

Combination Supplement

The dose recommended for the combination mineral supplement is 3 tablets three times daily for the relief of anxiety symptoms.[6]

Selenium

Selenium might be more effective when prescribed at 200 mcg per day. There should be no side effects when using a dose comparable to the one used in the study.[7]

Therapeutic Recommendation

Unlike the vitamins, the benefits of minerals are more or less due to the correction of a deficiency state. However, they can also be prescribed to patients who might have a mineral dependency where optimal supplementation would be a required factor in the correction of faulty metabolism.

In cases where there is a documented deficiency of calcium or magnesium, supplementation can produce substantial benefits. Selenium can be given to any patient struggling with anxiety because it might help and does not have any side effects associated with replacement dosages (100 to 200 mcg per day).

Evidence-Based Summary of Articles Demonstrating the Therapeutic Effectiveness of Minerals for the Treatment of Anxiety and/or Related Psychiatric Syndromes

Reference	Study Information	Grade
1	Two case reports demonstrating the resolution of anxiety once blood calcium levels were restored to normal.	C
4	Expert opinion and experimental data pertaining to the value of various B-vitamins (especially, thiamin, pyridoxine, and niacin/niacinamide) and magnesium for the treatment of anxiety neurosis.	D
5	Patient report, experimental data, and expert opinion demonstrating a relationship between chronic magnesium deficit and a syndrome characterized by weakness, latent tetany, anxiety, and psychosomatic disorders.	C
6	Expert opinion about a combination mineral supplement.	D
7	In a double-blind crossover study, 50 subjects received 100 mcg of selenium or placebo for 5 weeks. Those subjects with the lowest estimated level of selenium in their diets had a greater amount of reported improvements in symptoms of anxiety, depression, and tiredness following 5 weeks of supplementation.	A

References

1. Carlson RJ. Longitudinal observations of two cases of organic anxiety syndrome. Psychosomatics 1986;27:529-31.

2. Lawlor BA. Hypocalcemia, hypoparathyroidism, and organic anxiety syndrome. J Clin Psychiatry 1988;49:317-18.

3. Werbach MR. Case Studies in Natural Medicine. Tarzana, CA: Third Line Press, Inc., 2002:38.

4. Buist RA. Anxiety neurosis: the lactate connection. Int Clin Nutr Rev 1985;5:1-4.

5. Seelig MS, Berger AR, Spielholz N. Latent tetany and anxiety, marginal Mg deficit, and normocalcemia. Dis Nerv Syst 1975;36:461-65.

6. Walker M. A primary care physician's alternative for the benzodiazepines. J Orthomol Med 1990;5:169-73.

7. Benton D, Cook R. The impact of selenium supplementation on mood. Biol Psychiatry 1991;29:1092-98.

8. Werbach MR, Moss J. Anxiety. Textbook of Nutritional Medicine. Tarzana, CA: Third Line Press, Inc., 1999:110-15.

9. Durlach J, Bac P, Durlach V, et al. Neurotic, neuromuscular and autonomic nervous form of magnesium imbalance. Magnes Res 1997;10:169-95.

10. Werbach MR. Adverse effects of nutritional supplements. Foundations of Nutritional Medicine. Tarzana, CA: Third Line Press, Inc., 1997:133-60.

TREATING ANXIETY WITH AMINO ACIDS

Eight of the 22 amino acids that have been identified are considered essential because they cannot be made in the body and adequate amounts must, therefore, be present in the food. These are isoleucine, leucine, lysine, methionine, phenylalanine, threonine, tryptophan, and valine. The other 14 amino acids are inter-convertible in the body, and for this reason, have been labeled non-essential. These include arginine, tyrosine, glycine, serine, glutamic acid, glutamine, aspartic acid, taurine, carnitine, cystine, histidine, proline, alanine, and gamma-aminobutyric acid (GABA). They are all *essential*, however, and if there is a metabolic problem resulting in a deficiency of any of the 22, the results would be devastating to the body.

In the last several decades, there has been much more interest in studying the anxiolytic applications of specific amino acids, including ones from both the essential and non-essential groups. In this chapter, the clinical uses of glycine and GABA, as well as tryptophan and 5-hydroxytryptophan, are presented.

Glycine and GABA

Glycine is a nonessential (or neutral) amino acid that has profound anxiolytic properties. It is considered to be an inhibitory amino acid because it increases membrane permeability to chloride ions, producing an inhibitory postsynaptic potential (IPSP) and preventing action potential generation.[1] In other words, glycine works similarly to the benzodiazepines.

Receptors for glycine are found in the vertebrate CNS, spinal cord, and brain stem areas. They are equally distributed throughout mammalian tissues.[2] The highest concentrations of glycine are found in the thalamus, amygdala, substantia nigra, putamen, and globus palidus.[2]

Mechanism of Action

A unique aspect of glycine's mechanism of action has to do with its presumed antagonism of norepinephrine (NE).[3] The neurons for NE are located in a part of the brain stem called the locus coeruleus, from which the NE neurons branch out to touch as many as half of all the cells in the brain (probably several billion) in the cerebral cortex.[4] When an individual experiences anxiety or panic, NE is released from the locus coeruleus and affects a part of the brain known as the nucleus accumbens, leading to feelings of anxiety and panic.[3] Glycine antagonizes the release of NE from the locus coeruleus and the ensuing signals to the nucleus accumbens, thus mitigating anxiety and panic, as well as feelings of over-arousal.[3]

GABA also functions as an inhibitory neurotransmitter in the CNS. The mechanism of GABA's neuroinhibition is mediated through an increase in the permeability of post-synaptic membranes to chloride ions, leading to hyperpolarization. There is uncertainty if GABA can traverse the blood-brain barrier when administered orally.

GABA might have a therapeutic effect comparable to benzodiazepine medications and might be useful for patients addicted to them as well.[2] In a case report, a 40-year-old female patient with a history of severe anxiety was able to stop her diazepam and replace her lorazepam with 200 mg of GABA four times each day.[2]

Prescribing Glycine and GABA

Glycine

The best way to administer glycine is sublingually so that the gastrointestinal route is bypassed. This allows for quicker absorption, a faster onset of action, and swift entry to the CNS. At least 2 to 10 g are required in order to stop a panic attack.

It is very palatable and sweet tasting making it easy to administer sublingually. I have my patients place 2 g under their tongue at the onset of an acute panic attack. They can take another 2 g every few minutes until the panic attack subsides. It usually works within a few minutes.

Side effects are very rare when high doses are administered. There is one report that 14 g given to a 70-kg adult male produced nausea.[2] However, 15 to 30 g have been given to two manic patients producing no side effects except for cessation of the manic episode and calmness within one hour of supplementation.[2] I have not found glycine to work better than niacinamide for daily use. It is best reserved for acute panic attacks or acute periods of anxiety.

GABA

GABA should be prescribed at 2 to 3 g per day away from meals to aid with sleep, induce relaxation, and control symptoms of anxiety.[2] Even though side effects are rare, there is one report of neurologic tingling, flushing, transient hypertension, and tachycardia in a subject taking very high oral doses (10 g on an empty stomach) of GABA.[2] Smaller oral doses (1 to 3 g daily) of GABA was reported to cause neurologic tingling and flushing in several volunteer subjects.[2]

L-tryptophan and 5-hydroxytryptophan (Serotonin Precursors)

One theory of anxiety assumes dysregulation of the serotonergic system. Some of the positive therapeutic effects of SSRIs on anxiety result from serotonin augmentation within the CNS. In terms of increasing serotonin levels within the CNS, two amino acids (L-tryptophan and 5-hydroxytryptophan) appear to have favorable effects upon anxiety.

Mechanism of Action

In a small experimental study, 13 patients with hyperventilation syndrome (6 months to 3 years duration) were given baseline xanthurenic acid testing.[5] Hyperventilation syndrome is similar to anxiety and has shared features of increased respiration, frequent occipital headaches, and muscular hypertonia. Xanthurenic acid is a catabolite of tryptophan metabolism that is elevated or abnormal when there is a pyridoxine deficiency. In this study, it was elevated or low in 8 patients and was normal in the remaining 5. All patients were treated with 2 g of L-tryptophan each day, and 125 mg of pyridoxine three times each day.

Nine patients (70%) were free of attacks after 3 weeks of treatment. Repeat testing demonstrated that xanthurenic acid excretion was normal in all patients. Even though supplementation was discontinued after 4 weeks, the 9 patients who had a favorable response continued free of symptoms during 3 months of follow-up. The authors of this study theorized that a marginal deficiency of pyridoxine triggered the hyperventilation syndrome by causing serotonin depletion. Because both L-tryptophan and pyridoxine were the treatments in this study, it seems reasonable to attribute some of the therapeutic results to the use of L-tryptophan.

In a double-blind study, 45 patients with anxiety disorders were given 5-hydroxytryptophan (5-HTP), clomipramine, or placebo.[6] When the patients were on clomipramine, they had significantly better results on all the rating scales compared to placebo. 5-HTP was also effective and demonstrated a moderate reduction in terms of symptom reduction on a 90-item symptoms checklist and anxiety inventory. Unlike the clomipramine, 5-HTP did not reduce any symptoms of depression. The authors of this study concluded that serotonergic pathways are involved in the pathogenesis of anxiety disorders due to the positive results of these two treatments.

Prescribing L-trypophan and 5-hydroxytrytophan

L-tryptophan

The optimal dose of L-tryptophan appears to be 2 g daily in conjunction with vitamin B-6. To increase the availability of L-tryptophan to the brain and to augment its therapeutic effect, it is best taken on an empty

stomach with some type of carbohydrate (e.g., fruit juice).[7] In terms of side effects, the clinician needs to know that L-tryptophan can aggravate bronchial asthma and produce nausea when high doses are administered. Patients should avoid L-tryptophan if they are pregnant (can be harmful), are taking morphine (reduces effectiveness), have lupus (characterized by abnormal tryptophan metabolism), or have adrenal insufficiency (can be toxic).[7]

5-HTP

The optimal dose of 5-HTP is 200 to 900 mg in divided doses daily for at least 2 months.[8] The benefits of 5-HTP may also be improved by taking it with some type of carbohydrate.

Side effects are minimal but can include hypomania, mild nausea, vomiting, heartburn, and other gastrointestinal problems (e.g., flatulence, feelings of fullness, and rumbling sensations).[7,9]

Therapeutic Recommendation

Glycine is an excellent therapeutic agent for the immediate relief of acute panic attacks. It should not be used daily since there are other orthomolecular agents (e.g., niacinamide and oral vitamin B-12) that seem to be more efficacious when used regularly. Glycine can be recommended to patients as a backup when they have an acute exacerbation of their anxiety.

GABA appears to have a similar mechanism of action to that of glycine and may also be effective for acute panic attacks. There is some evidence that GABA can be effective when taken daily for chronic anxiety.

The serotonin precursors (L-tryptophan and 5-HTP) may also benefit patients suffering from anxiety disorders. These amino acids are not associated with any significant side effects. L-tryptophan and 5-HTP are good add-on treatments, but are probably not that effective when used by themselves for the treatment of anxiety disorders.

Evidence-Based Summary of Articles Demonstrating the Therapeutic Effectiveness of L-Glycine, GABA and Serotonin Precursors for the Treatment of Anxiety and/or Related Psychiatric Syndromes

Reference	Study Information	Grade
2	Expert opinion and some brief case reports about the therapeutic effectiveness of GABA and glycine.	C
3	Expert opinion about the usefulness of glycine for panic attacks.	D
5	Small experimental study on patients with hyperventilation syndrome who were given supplemental vitamin B-6 and L-tryptophan.	C
6	In a double-blind study, 45 patients with anxiety disorders were given 5-HTP, clomipramine, or placebo.	A

References

1. Nicoll RA. Introduction to the pharmacology of CNS drugs. In Katzung BG (ed.). Basic & Clinical Pharmacology. 6th ed. Norwalk, CT: Appleton & Lange. 1995:330.

2. Braverman ER, Pfeiffer CC, Blum K, et al. The Healing Nutrients Within. 2nd ed. New Canaan, CT, Keats Publishing, 1997;246-47, 247-58, 290-303.

3. Mitchell WA Jr. Foundations of Natural Therapeutics: Biochemical Apologetics of Naturopathic Medicine. Tempe, AZ: Southwest College Press, 1997;105-08.

4. Daigle RD, Clark HW, Landry MIM. A primer on neurotransmitters and cocaine. J Psychoactive Drugs 1988;20:283-95.

5. Hoes MJ, Colla P, Folgering N. Hyperventilation syndrome, treatment with L-tryptophan and pyridoxine; predictive value of xanthurenic acid excretion. J Orthomolec Psych 1981;10:7-15.

6. Kahn RS, Westenberg HG, Verhoeven WM, et al. Effect of a serotonin precursor and uptake inhibitor in anxiety disorders; a double-blind comparison of 5-hydroxytryptophan, clomipramine and placebo. Int Clin Psychopharmacol 1987;2:33-45.

7. Werbach MR. Foundations of Nutritional Medicine. Tarzana, CA: Third Line Press, Inc., 1997:141, 151-52, 188-89.

8. Werbach MR, Moss J. Anxiety. Textbook of Nutritional Medicine. Tarzana, CA: Third Line Press, Inc., 1999:110-15.

9. Murray M, Pizzorno J. Encyclopedia of Natural Medicine. Revised 2nd ed. Rocklin, CA: Prima Publishing, 1998:391-93.

TREATING CEREBRAL ALLERGY-RELATED ANXIETY

Any substance can potentially disrupt brain function and cause any form of neurosis, psychosis, or behavioral disorder. Such cerebral allergies are not limited to an antibody/antigen reaction causing an immunological event.

There are two distinct mechanisms by which cerebral allergies can cause disturbances in brain function. The first mechanism involves the direct pharmacological effects of substances or chemicals found in foods or beverages. The main culprits within this category are caffeine, alcohol, and sugar (glucose). The second mechanism involves masked, hidden, or delayed cerebral allergic responses to foods or beverages. These include wheat, milk, egg, and corn allergies.

Direct Pharmacological Effects of Caffeine, Alcohol, and Sugar

Caffeine

Caffeine is a stimulant and a widely-used psychoactive substance that can be the underlying cause of a patient's anxiety.[1] Caffeine can cause anxiety

in normal individuals, and it can be especially provoking to patients with pre-existing anxiety disorders.[2] Common somatic manifestations of caffeinism (in descending order of frequency) are diuresis, insomnia, withdrawal headache, diarrhea, anxiety, tachycardia, and tremulousness.[3] Caffeine has been shown to cause both anxiety and depressive symptoms, perhaps due to its ability to modify catecholamine levels, inhibit phosphodiesterase breakdown of cyclic AMP, and sensitize receptor sites.[4]

Side effects from caffeine consumption are common. In a published case report, caffeine use was associated with various symptoms, such as lightheadedness, tremulousness, breathlessness, headache, and premature ventricular contractions.[5] In the same patient, these symptoms went away once the caffeine was discontinued, and recurred on two occasions when caffeine was re-challenged after periods of abstinence.

In another study involving 21 anxiety patients and 17 normal controls, behavioral ratings, somatic symptoms, blood pressure, and plasma levels of 3-methoxy-4-hydroxyphenethyleneglycol (MHPG) and cortisol were assessed in all subjects after the oral administration of 10 mg of caffeine per kilogram of body weight.[6] The subjects with anxiety disorders had higher scores than the controls on self-ratings of anxiety, nervousness, fear, nausea, palpitations, restlessness, and tremors. The symptoms reported by the patients in the anxiety group significantly correlated with plasma caffeine levels. In fact, 71% of these patients found the behavioral effects of caffeine similar to those that occur during a panic attack. No differences were observed in plasma levels of MHPG, and both groups showed similar increases in their plasma cortisol levels. Since caffeine is an adenosine receptor antagonist, the authors of this study linked panic disorder with abnormalities in neuronal systems involving adenosine. The authors also recommended that all patients with anxiety disorders avoid caffeine.

Another study found a similar relationship between caffeine consumption and plasma cortisol levels.[7] The patients in the panic disorder and the control groups had an increase in their anxiety symptoms and plasma cortisol levels (not in plasma MHPG levels) following a caffeine challenge.

In yet another study, four male and two female patients with GAD or PD felt considerable relief from their anxiety symptoms when abstaining

from caffeine for more than 1 week.[8] Five of these patients were basically free of their anxiety during the 6 to 18 months of follow-up. The sixth patient required a low-dose benzodiazepine daily to remain asymptomatic while avoiding caffeine. All six patients re-experienced their anxiety when they were accidentally exposed to the stimulant.

These studies (and many more) demonstrate that vulnerable patients with a history of or susceptibility to anxiety are prone to exacerbations of anxiety when they consume any amount of caffeine. Since the severity of anxiety correlates with the amount of caffeine consumed, even 1 cup of coffee can be problematic for patients with anxiety disorders.[9] To make matters worse, patients who habitually consume caffeine are prone to withdrawal symptoms that mimic anxiety when the stimulant is discontinued.[10]

The best way to help patients with anxiety is to educate them about the importance of avoiding caffeine.

Alcohol

Alcohol has also been shown to aggravate or cause anxiety. It can inhibit gluconeogenesis from lactate and increase the lactate-to-pyruvate ratio, both of which are known to precipitate anxiety.[11] Alcohol has also been shown to increase anxiety under double-blind conditions.[12]

Ninety male patients who were given four different doses of ethanol (0.75 ml/kg), low-dose diazepam (0.12 mg/kg), high-dose diazepam (0.20 mg/kg), and placebo reported their feelings of anxiety on the Spielberger State Anxiety Inventory (STAI). There were significant increases in the STAI scores after subjects received the diazepam and ethanol administrations. When given the placebo, the subjects reported significant decreases in their self-reported tension levels.

Like caffeine withdrawal, discontinuing alcohol can cause anxiety and hyperventilation.[13] Thus, patients with anxiety should be advised to avoid alcohol.

Sugar

The ingestion of sugar appears to increase blood lactate levels, which causes anxiety in sensitive patients.

In one study, 60 patients were given 100 g of glucose in a cola-flavored

drink.[14] All subjects had their serum glucose, blood lactate and pyruvate, and adenosine triphosphate measured at regular timed intervals during the study. Of the 60 subjects, 8 of the schizophrenic patients (n=28) and 7 of the psychoneurotics (n=17) had a confirmed diagnosis of anxiety. The blood lactate levels were significantly elevated (P<0.001) in the anxiety patients from both the schizophrenic and psychoneurotic groups during the third, fourth, and fifth hours following the glucose challenge. Patients without a diagnosis of anxiety showed no significant changes in their blood lactate concentrations. The lactate-to-pyruvate ratios of the anxiety-prone subjects also showed marked differences compared to non-anxious patients. The anxiety subjects from the schizophrenic group had a positive shift in the lactate-to-pyruvate ratio of +29.4 compared to a shift of only +6.6 in schizophrenic patients without anxiety.

In the group of psychoneurotic patients with anxiety, the shift in the lactate-to-pyruvate ratio was +35.1, compared to a negative shift during the third-hour following the glucose challenge of -5.8 in the non-anxious psychoneurotic patients. Evidently, in the non-anxious group of psychoneurotic patients, their lactate-to-pyruvate ratios returned to within 0.5 of their fasting levels during the fifth hour following the glucose challenge.

In other studies, glucose infusions were shown to induce panic attacks and increase blood lactate concentrations in anxiety patients.[15-17] The results of these studies demonstrate marked differences in the ways anxiety patients metabolize blood sugar compared to non-anxious patients. It appears that anxiety patients are more likely to have an increased production of blood lactate levels following the administration of sugar.

Masked, Hidden, or Delayed Cerebral Allergic Responses

Patients who have avoided sugar, alcohol, and caffeine, and who have had several months of nutritional treatments without experiencing any consistent clinical benefits, should be evaluated for the presence of masked, hidden, or delayed cerebral allergies. Hidden allergies can be loosely defined as reactions to foods occurring hours after or even several days following the ingestion of allergenic foods.[18] The foods most commonly associated with allergic reactions are listed in Table 14.[18]

Such patients are probably unaware that their anxiety symptoms are related to what they have been habitually consuming. Symptoms reported by several patients after consuming common food allergens are listed in Table 15.[19]

Table 14: Foods Most Commonly Associated with Allergies

Dairy products	Citrus fruits
Wheat	Pork
Eggs	Rye
Corn	Beef
Chocolate	Tomato
Tea	Peanuts
Coffee	Barley
Sugar	Nuts
Yeast	Seafood
Soy	

Table 15: Symptoms Associated with Common Food Allergens

Wheat	Restless, tense, yawning, unable to concentrate, abdominal pain, and muscle spasm and pain at the posterior neck and back.
Milk	"Nervous," generalized headache, yawned, tired, dizzy, confused, irritable, restless, and sharp abdominal cramps with bloating.
Egg	Yawning, intermittent fatigue, nervous, and unable to concentrate.
Corn	Tense, irritable, fatigue, flushed face, visual blurring, and frontal headache

Specific Adaptation

To investigate whether or not cerebral allergies are involved in a patient's complaint of anxiety, the practicing clinician should familiarize himself with Randolph's theory of specific adaptation (Table 16).[20]

Table 16: Randolph's Modification of the GAS to Include Ecologically-Induced Illnesses

Stage 1: Preadaptive/ Nonadapted	In the nonadapted state, ingestion of foods to which one is susceptible (once in 4 days or less often) results in immediate acute symptoms.
Stage 2: Addiction	**2A (Adapted):** Food ingestion (once in 3 days or more often) does not produce acute symptoms, but the patient experiences no immediate ill effects or reports that he feels better. The patient may experience delayed withdrawal symptoms several hours later that can be mitigated by ingesting more of the same food. The withdrawal period can be sustained for long periods by eating a sufficient amount of the allergenic foods to maintain the patient in this adapted phase of food addiction. Both patients and their clinicians typically regard the transition between 2A and 2B as the "onset of the present illness."
	2B (Maladapted): The patient is unable to adapt adequately to withdrawal symptoms by eating more of the allergenic foods or by eating them more frequently. Chronic symptoms arise from the withdrawal reactions and include more advanced mental and behavioral syndromes that characterize this maladapted stage.
Stage 3: Postadaptive/ Nonadapted	A state of exhaustion, which is more likely to be approached than actually reached by patients.

Testing and Prescribing for Food Allergies

Food Diary

Patients presenting with complaints of anxiety might be fluctuating between stages 2A and 2B of Randolph's theory of specific adaptation. To identify the food allergy and thus eliminate it, these patients can complete a 7-day diet diary to list how often they consume common food allergens, how frequently they eat suspected foods in a given day, and how

much they consume. Patients should be instructed to report any symptoms that are increased or alleviated by ingesting certain foods.

Once the 7-day diet diary has been received, the clinician can assess if the patient's anxiety is related to foods chronically consumed. If the diet diary implicates some of the common food allergens, it is best for the clinician to suggest several options to help the patient pinpoint which specific foods are involved in any mood disturbances.

Four-Day Water FAst

The patient can complete a water fast for a minimum of 4 days. W.H. Philpott and A. Hoffer have reported on the techniques of water fasting, citing its usefulness in terms of diagnosing and treating cerebral allergies.[21,22] The water should be filtered or bottled. The patient can drink judicious amounts while fasting. Patients should be warned against consuming too much water because water intoxication can be associated with dilution of essential electrolytes (causing hyponatremia) and cardiac arrhythmias.

During the first 2 to 3 days of the water fast, it is not uncommon for patients to experience symptoms of food withdrawal (much like a hangover) because they are passing through the addictive withdrawal phase. Patients can also exhibit mild symptoms of tension, fatigue, headache, and dizziness, or more severe symptoms of psychosis, depression, hallucinations, delusions, and illogical aggression.

If the patient does not have any cerebral allergies to begin with, there will not be any reemergence of symptoms during the first few days of the fast. Withdrawal symptoms will usually abate by the fourth day, and the patient should be considerably better. If the withdrawal symptoms have not ameliorated by the fourth day, the water fast should be extended by 2 to 3 days. Patients having asthma, epilepsy, and diabetes, as well as those in a severely debilitated state, need to be monitored closely during the water fast because they can relapse.

Once the patient has returned to a normal state and the patient's anxiety has improved, it is time to test individual foods to see if they can produce the patient's anxiety symptoms. The water fast stabilizes a patient's neurophysiological state so an immediate reaction occurs when the patient is exposed to an allergenic substance.

Patients should test individual foods one at a time and every 4 days.

For example, to test milk, the patient would consume 1 to 2 glasses at breakfast, followed by water mid-morning, 1 to 2 glasses at lunch, followed by water mid-afternoon, then 1 to 2 glasses at dinner, and water before bed if necessary.

The patient is instructed to record all symptoms that occur immediately after drinking milk and for the next 3 days. Since cerebral manifestations can occur in a delayed fashion, the patient is instructed to abstain from testing other items for these 3 days. This process is done with other allergenic foods. The process typically takes 10 to 14 days to complete. If a patient has a severe allergic reaction to a tested food item, medical assistance might be needed in order to stop the reaction. To stop a serious reaction, vitamin C (with 1/2 cup of baking soda) can be provided to the patient at a dose of 4 g three times daily.

Elimination or Oligoantigenic Diet

Another option is to put the patient on an elimination or oligoantigenic diet, followed by individual food challenges.[18,23] This procedure is easier for patients than a 4-day water fast, although it is not as effective. An oligoantigenic or elimination diet contains as few allergens as possible (Table 17).[23,24]

Table 17: Example of a Daily Oligoantigenic Diet by Serving
One meat (lamb, turkey, or chicken)
Potatoes or rice
One fruit (pear, banana, or apple)
Brassica family of vegetables
Sunflower oil
Water or mineral water
Calcium gluconate (3 g/day)
Vitamins

Patients need to stay on the oligoantigenic diet for at least 3 to 4 weeks. Symptoms of food withdrawal tend to occur during the first few days of the diet while patients pass through the addiction phase. If no improvement

occurs after 3 to 4 weeks, it is likely that some of the oligoantigenic foods are themselves provoking reactions.

If this happens, an alternative oligoantigenic diet should be tried for an additional 2 to 3 weeks to see if the anxiety symptoms clear. Once the patient has experienced significant relief of his anxiety symptoms, it is time to do individual food challenges.

Food challenges are done in a similar manner to water fasting. The only difference is that the oligoantigenic diet is maintained throughout the testing or challenge period. The individual allergenic foods are tested every 4 days, and the entire challenge period usually takes an additional 2 to 3 weeks to complete.

Patients are instructed to record any symptoms that occur immediately after the individual food challenge at breakfast, lunch, and dinner. They should also record any symptoms that might arise over the next 3 days. After the first day of the food challenge, no other new foods are challenged or tested until the 3 days have passed; this approach helps to monitor for delayed cerebral reactions.

Dietary Modifications

Once patients complete the challenge phase of the water fast or the oligoantigenic diet, they should adopt new daily food practices. One way to manage their cerebral reactions effectively is to eliminate all allergenic foods from their diets and never (knowingly) consume them again. Another method involves a rotation diet where the allergenic foods can be consumed once every 4 days in order to limit possible cerebral reactions. This latter approach is somewhat easier for patients to follow, but can cause patients to re-enter Randolph's stages of 2A and 2B.

If patients are unwilling to try the water fast or oligoantigenic diet, they could simply avoid suspected allergenic foods for a time and see if their anxiety improves. This option is not as effective since it would be difficult to identify clearly the specific foods causing a patient's cerebral reactions.

Supplementation

In addition to the dietary modifications, many orthomolecular agents can prevent or reduce some of the cerebral reactions that patients are experiencing. According to C.C. Pfeiffer, a combination of dietary modifications

and nutrients can lower blood histamine levels or augment its catabolism.[25] A low-protein diet reduces the amount of ingested L-histidine, which is a precursor to histamine. Calcium helps mobilize bodily stores of histamine and might also increase histamine catabolism. Methionine lowers blood histamine by reacting with histamine to form N-methylhistamine, an inert methylated ring structure.

A. Hoffer has also reported on the anti-allergic properties of various nutrients.[22] He suggested that the regular use of niacin would decrease the concentrations of both histamine and heparin in the body as it releases these substances from mast cells. He also stated that vitamin C reduces allergic reactions by combining with histamine and facilitating detoxification. In a fairly recent publication, both niacin and vitamin C were shown to have a significant effect upon lowering and normalizing blood histamine.[26]

The clinician should also consider adding hydrochloric acid (HCl) supplementation to a patient's daily orthomolecular plan. Chronic allergies might be associated with impaired gastric acid secretion,[27] which could be improved with regular HCl supplementation at meals. For a thorough review of the physiological aspects of HCl and prescribing instructions, please refer to G.S. Kelly.[28]

Therapeutic Recommendation

Cerebral allergies should be considered in all patients who have not adequately responded to orthomolecular treatments. These brain manifestations or reactions can be caused by the direct pharmacological properties of specific substances, such as caffeine, alcohol, and sugar. They can also be caused by the regular consumption of common food allergens (e.g., milk, wheat, corn, and eggs), which can produce delayed, masked, or hidden cerebral allergies.

Effective treatments include avoiding caffeine, alcohol and sugar; and using a 4-day water fast or an oligoantigenic diet followed by specific food challenges. The use of a rotation diet and orthomolecular supplements may also help.

Lifetime avoidance of implicated foods might be the only effective way to manage cerebral allergies.

Evidence-Based Summary of Articles Demonstrating the Therapeutic Effectiveness of Food Allergy Treatments for Anxiety and/or Related Psychiatric Syndromes

Reference	Study Information	Grade
5	Case report demonstrating a relationship between coffee consumption and anxiety.	C
6	In a study involving 21 anxiety patients and 17 normal controls, behavioral ratings, somatic symptoms, blood pressure, and plasma levels of 3-methoxy-4-hydroxy-phenethyleneglycol (MHPG) and cortisol were assessed in all subjects after the oral administration of 10 mg of caffeine per kilogram of body weight.	B
7	Another study found a similar relationship between caffeine consumption and plasma cortisol levels. The patients in both the panic disorder and control groups had an increase in their anxiety symptoms and plasma cortisol levels (not in plasma MHPG levels) following a caffeine challenge.	B
8	In another study, four male and two female patients with GAD or PD felt considerable relief from their anxiety symptoms when abstaining from caffeine for more than 1 week.	C
12	Alcohol has been shown under double-blind conditions to increase anxiety. Ninety male patients, who were given four different administrations of ethanol (0.75 ml/kg), low-dose diazepam (0.12 mg/kg), high-dose diazepam (0.20 mg/kg) and placebo, reported their feelings of anxiety on the Spielberger State Anxiety Inventory (STAI).	B
14	In one study, 60 patients were given 100 g of glucose in a cola-flavored drink. The lactate-to-pyruvate ratios of the anxiety-prone subjects showed marked differences compared to non-anxious patients.	B

Reference	Study Information	Grade
15,16, 17	In these studies, glucose infusions were shown to induce panic attacks and increase blood lactate concentrations in anxiety patients.	B
19	Illustrative case reports of patients' cerebral reactions to various foods.	C
20	Expert opinion on the human adaptive response to commonly consumed foods and environmental chemical exposures.	D
21,22	Expert opinion and case reports about the therapeutic efficacy of elimination diets, water fasting, and other types of interventions. Also includes expert opinions and case reports demonstrating a link between foods and cerebral reactions.	C
23	Summary of controlled and experimental trials on the therapeutic efficacy of oligoantigenic diets or specific food allergy avoidances for the treatment of neurological and psychiatric disorders (does have a section on affective or mood disorders). The various cited studies would receive C and B grades.	B,C

References

1. Whalen R. Caffeine anaphylaxis: A progressive toxic dementia. J Orthomol Med 2003;18:25-28.

2. Broderick P, Benjamin AB. Caffeine and psychiatric symptoms: A review. J Okla State Med Assoc 2004;97:538-42.

3. Victor BS, Lubetsky M, Greden JF. Somatic manifestations of caffeinism. J Clin Psychiatry 1981;42:185-88.

4. Greden JF, Fontaine P, Lubetsky M, Chamberlin K. Anxiety and depression associated with caffeinism among psychiatric inpatients. Am J Psychiatry 1978;135:963-66.

5. Greden JF. Anxiety or caffeinism: A diagnostic dilemma. Am J Psychiatry 1974;131:1089-92.

6. Charney DS, Heninger GR, Jatlow PI. Increased anxiogenic effects of caffeine in panic disorders. Arch Gen Psychiatry 1985;42:233-43.

7. Uhde TW, Boulenger JP, Jimerson DC, et al. Caffeine: Relationship to human anxiety, plasma MHPG and cortisol. Psychopharmacol Bull 1984;20:426-30.

8. Bruce M, Lader M. Caffeine abstention in the management of anxiety disorders. Psychol Med 1989;19:211-14.

9. Boulenger JP, Uhde TW, Wolff EA 3rd, et al. Increased sensitivity to caffeine in patients with panic disorders. Preliminary evidence. Arch Gen Psychiatry 1984;41:1067-71.

10. Greden JF. Anxiety or caffeinism: A diagnostic dilemma. Am J Psychiatry 1974;131:1089-92.

11. Alberti KG, Nattress M. Lactic acidosis. Lancet 1977;2:25-29.

12. Monteiro MG, Schuckit MA, Irwin M. Subjective feelings of anxiety in young men after ethanol and diazepam infusions. J Clin Psychiatry 1990;51:12-16.

13. Roelofs SM. Hyperventilation, anxiety, craving for alcohol: A sub-acute alcohol withdrawal syndrome. Alcohol 1985;2:501-05.

14. Wendel OW, Beebe WE. Glycolytic activity in schizophrenia. In Hawkins D, Pauling L (eds.) Orthomolecular Psychiatry. San Francisco, CA: W. H. Freeman and Company, 1973:279-302.

15. Rainey JM Jr, Frohman CE, Freedman RR, et al. Specificity of lactate infusion as a model of anxiety. Psychopharmacol Bull 1984;20:45-49.

16. Maddock RJ, Mateo-Bermudez J. Elevated serum lactate following hyperventilation during glucose infusion in panic disorder. Biol Psychiatry 1990;27:411-18.

17. Maddock RJ, Carter CS, Gietzen DW. Elevated serum lactate associated with panic attacks induced by hyperventilation. Psychiatry Res 1991;38:301-11.

18. Gaby AR. The role of hidden food allergy/intolerance in chronic disease. Altern Med Rev 1998;3:90-100.

19. Mandell M. Cerebral reactions in allergenic patients. Illustrative case histories and comments. In Williams RJ, Kalita DK (eds.). A Physician's Handbook on Orthomolecular Medicine. New Canaan, CT: Keats Publishing, Inc. 1977;130-39.

20. Randolph TG. Specific adaptation. Ann Allergy 1978;40:333-45.

21. Philpott WH. Maladaptive reactions to frequently used foods and commonly met chemicals as precipitating factors in many chronic physical and chronic emotional illnesses. In Williams RJ, Kalita DK (eds.). A Physician's Handbook on Orthomolecular Medicine. New Canaan, CT: Keats Publishing, Inc., 1977;140-50.

22. Hoffer A. Treatment of schizophrenia. In Williams RJ, Kalita DK (eds.). A Physician's Handbook on Orthomolecular Medicine. New Canaan, CT: Keats Publishing, Inc., 1977;83-89.

23. Egger J. Food allergy and the central nervous system. Nestlé Nutrition Workshop Series, Volume 17. In Schmidt E (ed.). Food Allergy. New York, NY: Vevey/Raven Press, Ltd., 1988:159-75.

24. Egger J, Wilson J, Carter CM, et al. Is migraine food allergy? A double-blind controlled trial of oligoantigenic diet treatment. Lancet 1983;2:865-69.

25. Pfeiffer CC, Mailloux R, Forsythe L. The Schizophrenias: Ours to Conquer. Wichita, KS: Bio-Communication Press, 1970:159.

26. Prousky J, Lescheid D. Vitamins B_3 and C: Their role in the treatment of histadelia. J Orthomol Med 2002;17:17-21.

27. Eaton KK, Gaier HC, Howard M, et al. Gastric acid production, pancreatic secretions and blood levels of higher alcohols in patients with fungal-type dysbiosis of the gut. J Nutr Environ Med 2002;12:107-12.

28. Kelly GS: Hydrochloric acid: Physiological functions and clinical implications. Altern Med Rev 1997;2:116-27.

TREATING HYPOGLYCEMIA-
RELATED ANXIETY

⑪

A ny clinician interested in evaluating and treating a patient's anxiety should determine if hypoglycemia (low blood glucose or sugar) is causing some or all of the problems. Some research demonstrates that patients with anxiety have different metabolic rates of glucose than patients without anxiety.

In one study, patients with panic disorder were found to have different measured glucose rates than control subjects in the following brain areas: hippocampus, left inferior parietal lobule, anterior cingulate, and the medial orbital frontal cortex.[1]

In another study, three of nine patients with panic disorder developed symptomatic hypoglycemia, but not panic attacks, when given standard glucose tolerance tests.[2] Although the authors concluded that hypoglycemia is an unlikely cause of "spontaneous" panic attacks, it is clear that there are some metabolic differences in the ways anxiety patients manage their blood sugar levels. These differences might cause such patients to be more susceptible to chronic anxiety.

Diagnosing Hypoglycemia

Symptoms

The central nervous system has an absolute requirement for a continual supply of blood-borne glucose to serve as the primary source of energy for its metabolic functions. Periodic episodes of hypoglycemia can cause both adrenergic and neuroglycopenia symptoms (Table 18).[3]

Table 18: Symptoms of Hypoglycemia	
Adrenergic (mediated by epinephrine)	**Neuroglycopenia** (mediated by brain debt of glucose)
Angina	Abnormal mentation
Anxiety	Amnesia
Flushing	Behavioral change
Hunger	Blurred vision
Irritability	Brief episodes of aphasia
Nausea	Brief episodes of hemiplegia
Nervousness	Coma
Pallor	Confusion
Palpitations	Difficulty waking in the morning
Sweating	Dizziness
Tremulousness	Feeling cold
	Headache
	Lack of Coordination
	Organic personality syndrome
	Paresthesias
	Seizures
	Senile dementia
	Tiredness
	Weakness

(Adapted from: Bakerman S, Bakerman P, Strausbauch P. Glucose, hypoglycemia. ABC's of Interpretive Laboratory Data. 3rd ed. Myrtle Beach, SC. Interpretive Laboratory Data, Inc., 1994:258-60).

Laboratory Tests

Since many of the symptoms of hypoglycemia can be confused with cerebral allergies, it is important that each of these conditions is evaluated. Most patients cannot be classified as having frank hypoglycemia since they do not have a fasting plasma glucose (FPG) measurement of less than 50 mg/dL (2.8 mmol/L). When glucose levels are in the 45 to 50 mg/dL (2.48-2.8 mmol/L) range, the majority of patients would be considerably symptomatic.[3]

The problem with diagnosis is that a FPG test provides a single measurement at one point in time and, therefore, cannot provide adequate information as to how a patient might be regulating his blood glucose in response to meals or other metabolic stresses. More reliable assessments of hypoglycemia can be accomplished by administering functional laboratory tests of glucose tolerance.

The first test is the 2-hour post-prandial glucose test. This might be the most practical test since a very common problem with glucose dysregulation occurs among patients suffering from reactive (relative or functional) hypoglycemia, that is, when they experience precipitous drops in blood glucose a few hours after eating meals.

The second functional test is the 5-hour glucose tolerance test.[4] To do this test properly, the patient needs to fast for at least 10 to 12 hours after the evening or suppertime meal the day before the test. Water is allowed, but coffee and smoking are not. The next morning a FPG measurement is done as a baseline, and then the patient is provided with a 100-gram flavored glucose drink. At intervals of 0.5, 1.0, 2.0, 3.0, 4.0, and 5.0 hours, plasma glucose measurements are obtained. The patient is continually monitored for the presence of hypoglycemic symptoms.

There are slightly different methods of administering the glucose tolerance test than the one described. The time duration can be modified to 4 hours or increased to 6 hours, and the glucose drink can be 75 g instead of 100 g if desired.

To interpret the results, refer to Table 19.[4] Other published sources vary slightly in their interpretations of the 5-hour glucose tolerance test; the clinician is advised to review them before running this test on patients.[5,6]

Table 19: Interpreting the 5-Hour Glucose Tolerance Test

Normal	No elevation greater than 160 mg %; below 150 mg % at end of first hour; below 120 mg % at end of second hour.
Flat (no hypoglycemia)	No variation more than ± 20 mg % from fasting value (probably due to altered gastrointestinal absorption).
Relative (reactive or functional) hypoglycemia	A normal 2 or 3 hour response curve, showing a decrease of 20 mg % from fasting level during the final two hours.
Probable relative hypoglycemia	Same as relative hypoglycemia, except there is a decrease of 10 to 20 mg % from below fasting level.
Flat (hypoglycemia)	An elevation of 20 mg % or less, followed by a decrease of 20 mg % or more below the fasting level.
Pre-diabetic hypoglycemia	A 2-hour response identical to the pre-diabetic, but showing a hypoglycemic response during the final 3 hours.
Hyperinsulinism	A marked hypoglycemic response, with a value of less than 50 mg % during the third, fourth, or fifth hour.

(Adapted from: Beebe WE, Wendel OW. Preliminary observations of altered carbohydrate metabolism in psychiatric patients. In Hawkins D, Pauling L (eds.). Orthomolecular Psychiatry. San Francisco, CA: W. H. Freeman and Company, 1973:439).

Eating Habits

In some susceptible patients, the ingestion of a predominately carbohydrate meal or glucose drink causes an abrupt rise in plasma glucose, which signals the pancreas to secrete an abnormally high level of insulin. In the study from which Table 19 was derived, the patients with a diagnosis of psychoneurosis (an older term indicating anxiety) had the most frequent

episodes of hyperinsulin responses during the administration of the 5-hour glucose tolerance test.[4] Such a high insulin output would cause an abrupt drop in plasma glucose and adrenergic symptoms that are mediated through elevated epinephrine.

Epinephrine is one of two hormones (the other glucagon from the pancreas) that play a role in the short-term regulation of blood glucose. Epinephrine promotes glycogenolysis and lipolysis, inhibits insulin secretion, and inhibits the insulin-mediated uptake of glucose by peripheral tissues. Glucagon stimulates hepatic glycogenolysis and gluconeogenesis. The glucoreceptors in the hypothalamus respond to abnormally low concentrations of blood glucose by triggering neuroglycopenic symptoms and the output of both epinephrine (mediated through the autonomic nervous system) and adrenocorticotropic hormone (ACTH). The long-term regulation of blood glucose is additionally managed by cortisol from the adrenal glands and growth hormone (GH).

Associated Anxiety

Even though the body has many overlapping mechanisms to guard against hypoglycemia, the patient struggling with anxiety is probably putting added stress on these systems. The end result is poor blood glucose regulation, leading to eating behaviors that serve to potentiate this dysfunctional process, more stress on glucose regulatory systems, and numerous bouts of anxiety and/or panic attacks.

We are all equipped to deal with transient episodes of low blood glucose on an occasional basis. It is customary for these regulatory mechanisms to go into full force when a meal is missed or delayed, when too many sweets are consumed, when exercise is overdone, or from temporary vitamin and mineral deficiencies.

The typical anxiety patient, by contrast, has been eating poorly for months or years, has a variety of nutrient dependencies, and is unaware that his episodes of anxiety and/or panic are related to diet, metabolic stress, and episodes of hypoglycemia. Refined foods and sweets tend to be the cornerstones of the anxiety patient's diet. This leads to a chronic state of inadequate nutrition, overwhelmed blood glucose regulatory systems, and an inability to cope.

Treating Hypoglycemia

The primary therapeutic approach to hypoglycemia is to modify the patient's diet (Table 20).

Table 20: Treating Hypoglycemia with Dietary Modifications

1. The macronutrient proportions of the patient's diet should be amended so it is low in carbohydrates, moderately high in protein (including animal protein) and fat. If the patient does not respond adequately after several weeks, consider changing the macronutrient proportions to include a greater proportion of complex carbohydrates and less protein and fat.

2. Advise the patient to choose palatable and nutritious foods that have a low glycemic index.

3. Alcohol and caffeine should be avoided because these agents can cause hypoglycemia.

4. The diet should contain minimal amounts of common food allergens.

5. Eat six small meals each day instead of the typical three main meals.

6. If medically appropriate, perform aerobic exercise for a minimum of 30 minutes three times each week because exercise improves tissue sensitivity to insulin.

Diet Options

There are two different diets that can be recommended to patients with hypoglycemia. The first option involves a diet with a moderately high amount of protein and fat. Fat in moderately high amounts will slow down the entry of glucose into the bloodstream. Protein in moderately high amounts will decrease the release of insulin from the pancreas. If the protein-to-carbohydrate ratio (gram/gram) is 0.75 or greater, the insulin release from the pancreas with be slowed down and the subsequent decline in blood glucose following meals will not be as rapid.[7] In terms of the exact macronutrient percentages, a diet with moderately high amounts of protein and fat should contain about 40% carbohydrates, 30% protein, and 30% fat.[8] These proportions are similar to hunter-gatherer populations and this diet will encourage a superior level of health.

The second option involves a diet predominately high in complex (unrefined) carbohydrates. Complex carbohydrates include whole wheat, rice, corn, winter squash, potatoes, and lentils. These foods slow the entry of glucose into the bloodstream, promote regular bowel function, and create a feeling of satiety with fewer calories. To develop such a diet, the proportions of complex carbohydrates would need to be around 50% to 55%, protein at 15% to 20%, and fat at 30% to 35%. The amount of plant fiber derived from such a diet is 50 g each day, and the total amount of simple carbohydrates would be limited to 50 g per day as well. To follow this diet properly, it would be necessary to avoid or substantially reduce the intake of milk and fruit (including fruit juices). This diet has been clinically tested with patients diagnosed with reactive hypoglycemia.[9] It was shown to improve their reactive hypoglycemia by increasing insulin sensitivity and facilitating the uptake of glucose. With the substantial intake of soluble fiber, there was a delay in gastric emptying, a reduction in glucose absorption, and more stability of blood glucose concentrations.

In my clinical experience, the first diet is preferable because most patients seem to enjoy a more marked subjective benefit. Changing the diet to include more protein and fat should stabilize the blood sugar regulatory mechanisms and reduce or prevent frequent episodes of anxiety and/or panic attacks.

This dietary approach was the subject of a published report on dysglycemia (a functional term indicating poor blood glucose control and symptoms of hypoglycemia).[10] The patient described in this report had clinical improvements (i.e., less muscle ache and more weight loss) and reductions in her dysglycemia score (a questionnaire assessing the severity of hypoglycemia symptoms) from an initial value of 109 to 39 after being on a protein- and fat-based diet for a total of 4 weeks.

Chromium Supplements

Among the orthomolecular agents that could be offered to anxiety patients, chromium has the most documented evidence to support its use as a blood-glucose-stabilizing molecule. For many years, chromium was thought to be involved in the glucose-tolerance factor (GTF) molecule that presumably increases insulin sensitivity. The composition of GTF, as isolated from yeast, is made of chromic ion, nicotinic acid, and the amino

acids glycine, glutamic acid, and cysteine.[11] However, GTF has never been found in human tissues.

More recently, a naturally occurring oligopeptide low-molecular weight chromium-binding substance (LMWCr) has been proposed to be the biologically active form of chromium.[12] This compound has been found in many different mammals and is widely distributed in numerous tissues (e.g., liver, kidney, spleen, intestine, testicles, and brain).

This oligopeptide comprises the amino acids glycine, cysteine, glutamic acid, and aspartic acid. It has a multinuclear chromic assembly, in which the chromic centers are bridged by the anionic ligands, oxide, and/or hydroxide.[12] This LMWCr compound is part of an insulin amplification system that regulates glucose homeostasis through a complex series of biochemical reactions occurring at the insulin receptor.[13,14]

In one double-blind crossover experimental design study, 8 female patients were given 200 mcg of supplemental chromium (chromic chloride) for 3 months.[15] Supplementation improved the hypoglycemic symptoms and raised the minimum serum glucose values 2 to 4 hours following the glucose load. Other improvements included an increase in the insulin receptor number and the binding of insulin to red blood cells. The authors of this study linked the etiology of hypoglycemia to impaired chromium nutrition and/or metabolism.

In another study, 20 patients with clinical symptoms of hypoglycemia were given 125 mcg of a yeast chromium supplement for 3 months.[16] Prior to taking chromium, 19 of 20 subjects had a minimal glucose level in the tolerance curve above 2.2 mmol/L (40 mg/dL), which is the limit for glucose-induced hypoglycemia. The patients were assessed by the use of a glucose tolerance test (1 g of glucose/kg of body weight) and by an interrogation scheme. After 3 months of supplementation, 11 of 15 patients (73%) had improvements in the negative part of the glucose tolerance curve (i.e., the part of the curve being below the fasting level). Subjectively, the patients reported improvements in hypoglycemic symptoms of chilliness, trembling, emotional instability, and disorientation. Thus, chromium, as part of the LMWCr, should have the ability to improve glucose tolerance, increase insulin sensitivity, and reduce hypoglycemic symptoms.

In terms of toxicity, D.W. Lamson and S.M. Plaza have summarized the chromium literature, evaluating its mechanisms of action and exceptional

safety profile. According to these investigators, "there is no demonstration of general chromium toxicity in animals at a dose that would extrapolate to humans as 1050 mg daily."[17] One of these investigators has prescribed 3000 to 4000 mcg of chromium as nicotinate, given twice daily, to adult-onset diabetic patients over months and years, resulting in significant reductions of glucose and lipid levels without any increases in blood urea nitrogen, liver enzymes, or other laboratory abnormalities. Note that supplemental doses of chromium would never come close to 1050 mg per day.

Therapeutic Recommendation

Hypoglycemia, especially the reactive-type, is probably more common among anxiety patients than is currently believed. The symptoms of hypoglycemia and anxiety are quite similar. To do a proper work-up, it might be necessary to do functional glucose testing instead of the standard fasting plasma glucose measurement. Effective treatment strategies require strict dietary modifications and the regular use of supplemental chromium (125 to 200 mcg per day).

Evidence-Based Summary of Articles Demonstrating the Therapeutic Effectiveness of Dietary Modifications or Supplemental Chromium for the Treatment of Hypoglycemia

Reference	Study Information	Grade
5,6	Expert opinions and case reports of patient responses to dietary modifications (mostly protein-based diets).	C
10	Expert opinion and a patient's therapeutic response to a diet low in carbohydrates and moderately high in protein (including animal protein) and fat.	C
15	A double-blind crossover experimental design study of eight female patients who were given 200 mcg of supplemental chromium (chromic chloride) for 3 months.	B
16	A study of 20 patients with clinical symptoms of hypoglycemia that were administered 125 mcg of a yeast chromium supplement for 3 months.	B

References

1. Nordahl TE, Semple WE, Gross M, et al. Cerebral glucose metabolic differences in patients with panic disorder. Neuropsychopharmacology 1990;3:261-72.

2. Uhde TW, Vittone BJ, Post RM. Glucose tolerance testing in panic disorder. Am J Psychiatry 1984;141:1461-63.

3. Bakerman S, Bakerman P, Strausbauch P. Glucose, hypoglycemia. ABC's of Interpretive Laboratory Data. 3rd ed. Myrtle Beach, SC: Interpretive Laboratory Data, Inc., 1994:258-60.

4. Beebe WE, Wendel OW. Preliminary observations of altered carbohydrate metabolism in psychiatric patients. In Hawkins D, Pauling L (eds.). Orthomolecular Psychiatry. San Francisco, CA: W. H. Freeman and Company, 1973:434-51.

5. Currier W, Baron J, Kalita DK. Hypoglycemia: The end of your sweet life. In Williams RJ, Kalita DW (eds.). A Physician's Handbook on Orthomolecular Medicine. New Canaan, CT: Keats Publishing, Inc., 1977:156-60.

6. Newbold HL. Hypoglycemia: The Great Impersonator. Mega-Nutrients for Your Nerves. New York, NY: Peter H. Wyden, 1975:70-97.

7. Westphal SA, Gannon MC, Nuttall FQ. Metabolic response to glucose ingested with various amounts of protein. Am J Clin Nutr 1990;52:267-72.

8. Eaton SB, Konner MJ. Paleolithic nutrition: A consideration of its nature and current implications. N Engl J Med 1985;312:283-89.

9. Anderson JW, Gustafson NJ. Dietary fiber in disease prevention and treatment. Compr Ther 1987;13:43-53.

10. MacIntosh A. Dyslgycemia: A misunderstood functional illness. J Naturopath Med 1997;7:78-83.

11. Toepfer EW, Mertz W, Polansky MM, et al. Preparation of chromium-containing material of glucose tolerance factor activity from Brewer's yeast extracts and by synthesis. J Agric Food Chem 1977;25:162-66.

12. Vincent JB. Quest for the molecular mechanism of chromium action and its relationship to diabetes. Nutr Rev 2000;58:67-72.

13. Davis CM, Vincent JB. Chromium in carbohydrate and lipid metabolism. J Biol Inorg Chem 1997;2:675-79.

14. Vincent JB. Mechanisms of chromium action: Low-molecular-weight, chromium-binding substance. J Am Coll Nutr 1999;18:6-12.

15. Anderson RA, Polansky MM, Bryden NA, et al. Effects of supplemental chromium on patients with symptoms of reactive hypoglycemia. Metabolism 1987;36:351-55.

16. Clausen J. Chromium induced clinical improvement in symptomatic hypoglycemia. Biol Trace Elem Res 1988;17:229-36.

17. Lamson DW, Plaza SM. The safety and efficacy of high-dose chromium. Altern Med Rev 2002;7:218-35.

MAIN THERAPEUTIC OUTCOMES

⑫

With sufficient treatment time, the net result of the orthomolecular approach would be to dampen the autonomic nervous system (ANS) and facilitate tuning plasticity (TP), thereby improving symptoms of anxiety significantly. Overall, effective orthomolecular treatments help patients to regain enough confidence about engaging in their lives with markedly less anxiety and less fear of anxiety.

Dampening the ANS

The initial therapeutic result of the orthomolecular approach is to calm down or dampen the ANS. Anxiety might, in part, be related to a genetic survival mechanism that stimulates the ANS in response to perceived threats. It has even been suggested that anxiety, panic, or frenzy (hyperactive disorders) are all linked to the same brain-controlled survival mechanism that gets triggered from threats manifesting as "run-for-life" (flight) or "fight-for-life" experiences.[1] Thus, it makes good sense

that a diminution of the ANS would reduce anxiety in the majority of patients.

Facilitating TP

The next therapeutic result of the orthomolecular approach is to lessen the ANS response for a sufficient length of time (usually 6 to 12 months) so that the neural circuitry of the brain can have the necessary time to "fix" itself. The neural circuitry of the brain undergoes a conformational change referred to as plasticity or neuroplasticity, which is defined as the lifelong ability of the brain to coordinate its components to enable mental functioning.[2] The specific aspect of the brain's neuroplasticity directly involved in adapting and changing its neural circuitry (e.g., neuronal dendrites and spines) over days to weeks is known as tuning plasticity (TP).[2] When the TP cannot adapt and change (i.e., it is too rigid), this is called insufficiency of tuning plasticity (ITP), and the result is possible mood and anxiety disorders.[2] In other words, when the brain cannot remodel itself due to ITP, it can remain locked in a habitual pattern of anxiety (i.e., chronic anxiety and/or episodes of panic attacks).

It has been hypothesized that antidepressant and anti-anxiety medications facilitate TP, allowing the neural circuitry of the brain to readapt to experiences that would otherwise have caused mental dysfunction and symptoms.[2] It is highly likely that orthomolecular treatments also encourage TP.

I am of the opinion that orthomolecular treatments are more effective than pharmaceuticals at encouraging TP. By definition, orthomolecular compounds are found naturally in the human body (unlike pharmaceuticals), are significantly less toxic (unlike pharmaceuticals), and nourish the central nervous system (unlike pharmaceuticals). These factors probably allow the patient to receive a greater degree of TP while on orthomolecular treatments, enabling the patient to recover from his symptoms of anxiety markedly.

References:

1. Polani PE. Attacks of anxiety, panic and frenzy, and their related depression: A hypothesis. *Med Hypotheses* 2004;63:124-27.

2. Peled A. From plasticity to complexity: A new diagnostic method for psychiatry. *Med Hypotheses* 2004;63:110-14.

ACKNOWLEDGMENTS

First, I would like to thank my wife, Robin. Many positive, wonderful, and fulfilling things have happened in my life since December 14, 2003 – the day we met.

I thank my parents for always doing whatever they can for me. Without their support and encouragement, I would not be practicing as a naturopathic doctor.

I would also like to thank Abram Hoffer, PhD, MD, of Victoria, British Columbia. He has been a true inspiration and a mentor (without knowing it) since I learned of the term "orthomolecular." Dr Hoffer's observations, writings, and concepts have greatly influenced my thinking and my work with patients. I am thankful for his warmth and generosity during the filming of the DVD, *Anxiety Disorders: Grand Rounds*.

I am indebted to all my patients, especially those struggling with the debilitating symptoms of anxiety. Only through my clinical work have I been able to learn about and experience the benefits of the restorative orthomolecular approach.

Lastly, I am thankful for the support of my employer, The Canadian College of Naturopathic Medicine, located in Toronto, Ontario. Many people (past and present) at this exceptional institution have helped me personally and professionally.